T0163433

Althusser and Art

Althusser and Art

Jonathan Fardy

Winchester, UK
Washington, USA

JOHN HUNT PUBLISHING

First published by Zero Books, 2020
Zero Books is an imprint of John Hunt Publishing Ltd., No. 3 East St., Alresford,
Hampshire SO24 9EE, UK
office@jhpbooks.com
www.johnhuntpublishing.com
www.zero-books.net

For distributor details and how to order please visit the 'Ordering' section on our website.

Text copyright: Jonathan Fardy 2018

ISBN: 978 1 78904 307 5
978 1 78904 308 2 (ebook)
Library of Congress Control Number: 2019931657

A CIP catalogue record for this book is available from the British Library.

Design: Stuart Davies

UK: Printed and bound by CPI Group (UK) Ltd, Croydon, CR0 4YY
US: Printed and bound by Thomson-Shore, 7300 West Joy Road, Dexter, MI 48130

Contents

Acknowledgements

I want to thank the good people at Zero Books for agreeing to publish this short text and for their dedication to thinking about radical politics and theory in new ways for new times. It was not long after submitting this text for review that I learned that I am for the first time a father to be. I dedicate this book to that future and my wife, Amy Wuest, Ph.D., who continues to be my most trusted intellectual interlocutor and my partner in all things political and philosophical.

Chapter 1

Introduction

The thought of Louis Althusser (1918-1990) seemed for a long time to have been eclipsed by history. Althusser's life-long battle with depression and anxiety culminated in the killing of his wife, Hélène Rytman in 1980 and his subsequent confinement to a mental institution for five years. Less than a decade later, the Berlin Wall fell, followed by the collapse of the Soviet Union and finally Althusser's death. Marxism, and especially Althusserian or "structuralist" Marxism, slipped into the rearview mirror. So why now return to Althusser? And why return to his aesthetics? Let me take each of these questions in turn.

Return to Althusser?

"Return" is a key term in Althusser's lexicon. In 1965 with the publication of *For Marx* and *Reading Capital*, Althusser called for a "return to Marx" (which closely paralleled Jacques Lacan's call for a "return to Freud"). Althusser's call for a return to Marx was a call to shed the burden of established *readings*. Althusser's new reading of Marx produced a new theory of reading itself. Althusser developed a theory of "symptomatic reading," a mode of reading attentive to the symptomatic way in which Marx's texts are marked by epistemological stress points. These points of stress, Althusser argued, resulted from Marx's effort to think within the discursive constraints of inherited epistemological forms – Ricardian economics, Hegelian philosophy, and nineteenth-century materialism – and Marx's effort to theoretically transcend the limits imposed by these forms of thought. To return to Marx meant a break, even an "epistemological break," with the ways of knowing and reading Marx long established in the political and theoretical

"conjunctures" of historical class struggle.

What I propose is a return to Althusser in a similar sense; I propose a new way of reading Althusser's political theory in light of his few writings on art and aesthetics. I will argue that Althusserianism is not only an explicit political theory, but an immanent and implicit aesthetic theory. Althusserianism is a thinking according to a certain aesthetic of theory itself. What I call Althusser's "theory of theory" is a theory that thinks in and through aesthetics.

Althusser's Aesthetics?

The phrase "Althusser's aesthetics" may surprise some. To be sure, his work is not principally identified with aesthetic theory. However, many of his most esteemed students, especially Jacques Rancière and Pierre Macherey, have centered their post-Althusserian Marxist theorizing around the question of art and aesthetics. This very fact indicates that there was something in the discourse of Althusserianism that led to reflections on the relation between aesthetics and politics. But more centrally, in Althusser's work itself, we find a trace of aesthetic theorizing in *Reading Capital*, especially in Althusser's theorization of "symptomatic reading," which is a form of reading that functionally reads Marx's texts as a kind of literature marked by particular, peculiar, and symptomatically revealing words and rhetorical constructions. Moreover, Althusser wrote two important essays on art. He wrote on the theatre of Carlo Bertolazzi in *For Marx* and the paintings of Leonardo Cremonini in *Lenin and Philosophy*. This book will work from these peripheral writings back to the center of Althusser's theoretical work in order to show the profound connection between Althusser's reflections on art and his political theory. But I will also show how Althusserianism can be functionally reconstructed as "raw material," in François Laruelle's sense, for the production of a new form of aesthetico-critical theory that compels serious

2

consideration of the role that aesthetics plays in the practice of theorizing.

Aims and Chapter Outlines

My aim in the next four chapters is two-fold. The first is to delineate the contours of Althusser's aesthetics and to show how this maps onto and transforms how we can read Althusser's early work. The second aim is to establish an invented genealogy of Althusserianism as the search for an *aesthetic form* for the surpassal of the theory-practice dialectic. Chapter one examines the origins of Althusserianism as articulated in *For Marx* and *Reading Capital* of 1965. Chapter two examines Althusser's two articles on aesthetics and shows how his readings of theatre and painting reveals a paradox at the heart of Althusserian theory that politically manifests as the difference between manual and mental labor. Chapter three focuses on the work of Rancière and Macherey. Rancière's 1974 critique of Althusserianism, *Althusser's Lesson,* marked Rancière's break with his former teacher and would lead him to consider the educative and theoretical apparatuses that, like Althusserianism, reproduce the division of labor and the inequality of intelligences enshrined in capitalist relations. The chapter also explores Macherey's 1966 text, *A Theory of Literary Production,* which is in large part an application of Althusserian theory to the study of literature and literary form. The very existence of *A Theory of Literary Production* testifies to the dimension of aesthetic reflection immanent in Althusserian theory. Through the critique and affirmation of Althusserianism, represented by Rancière and Macherey respectively, we can better grasp the aesthetic legacies immanent to the Althusserian mode of theoretical production. I then turn to the work of François Laruelle and his theory of non-philosophy, and in particular his concept or "clone" of "raw material," to reconstruct Althusserian theory as an aesthetic and creative practice of theorizing. Finally, I place Althusserianism

in an invented genealogy, stretching from Karl Korsch through Althusser and his students to Laruelle, as the search for a form of theorizing that aimed to surpass the theory-practice dialectic and the idealism that underwrites that dialectical construction. Chapter five offers a conclusion and a view to the future prospects for reorienting theory as aesthetic practice.

Chapter 2

Theoreticism

The recent publication of *The Concept in Crisis: Reading Capital Today*, edited by Nick Nesbitt, is something of a clarion call for a return to an unashamed "theoreticism" if not Althusserianism *tout court*. No doubt a major impetus for this call to return to Althusser's famed "return to Marx" is Nesbitt's theoretical project to trace the epistemological trajectory of the "philosophy of the concept" from Jean Cavaillès, to Louis Althusser, to Alain Badiou. Nesbitt's epistemological reading of the emergence of Althusserianism itself returns to the "problematic" of the concept of the "epistemological break" on which Althusser based his reading of Marx's corpus.

Althusser's contention, in *For Marx*, that between the works of the "young" Marx (of the *1844 Manuscripts* especially) and the "scientific" Marx (of *Capital*) there is an epistemological break, fundamentally structured his claim that the work of the young Marx was "ideological" whereas that of the mature Marx was "scientific." The epistemological break at issue is that between the specter of Hegel (idealism) and Marx himself (historical materialism).

Nesbitt does something similar via his return to Althusser. Nesbitt, however, returns us to Althusser's "scientific" or "theoreticist phase" – his earliest phase – marked by his two early landmark publications, *For Marx* and *Reading Capital*. It is this first phase, and especially Althusser's theoreticist concept of theory, his *theory of theory* that is the primary focus of this book. Before continuing, however, it will be useful to situate and contextualize the emergence and development of Althusserianism.

Althusserianism in Context

Althusser's "theoreticism" came under scrutiny from a host of dissenting Marxist scholars (notably E.P. Thompson) and the official philosophers of the French Communist Party (PCF). Althusser too in time submitted his theoreticism to self-critique, especially in *Lenin and Philosophy*. Althusser there admonished his theoreticist work for according primacy and autonomy to theoretical practice rather than class struggle. I call this Althusser's "Leninist Phase." Thereafter, Althusser would define Marxist philosophy as "class struggle in theory." Finally, after his death, a long, unfinished manuscript was discovered in which Althusser had sketched a new theory of "aleatory materialism." This late phase drew attention to the historical and political contingencies that structure class struggle and revolution. We can schematize Althusser's three phases thus:

1. Theoreticist Phase: "Theoretical practice ... works on raw material (representations, concepts, facts)."[1]
2. Leninist Phase: "Philosophy represents the class struggle in theory."[2]
3. Aleatory Phase: "the encounter may not take place, just as it may take place ... it is of the order of a game of dice."[3]

Althusser's concept of theory – his *theory of theory* – transformed over the course of the three phases. But the one constant was Althusser's concern to specify what theory is and what its role in Marxist struggle should be. Let us now turn to a closer examination of Althusser's theoreticist phase in order to prepare the way for the chapters to come.

Against Humanism

Althusser's "return to Marx" was also a turn away from the USSR. The point of emergence for Althusser's theoreticism (as he himself noted often) was Soviet Premier Nikita Khrushchev's

so-called "secret speech" delivered at the Twentieth Congress of the Communist Party in 1956. Khrushchev's speech denounced Stalin's crimes. He laid the blame for Stalinism on Stalin's "cult of personality." Stalin had, Khrushchev claimed, arrogantly arrogated socialist struggle for the purposes of his selfish consolidation of power and narcissistic reification. Khrushchev's proposed ideological corrective was "Marxism-humanism." Soviet socialism had now to return to the *true humanism* of Marx. The secret speech served to accelerate the Sino-Soviet split. Chinese communists (and those elsewhere) denounced the speech as "reformism." But, the French communist party (PCF) took the speech as marching orders. Stalinism was out; Marxism-humanism (or socialist-humanism) in. Althusser dissented. From his vantage at the reigning institution of higher education in France, École Normale Supériere (ENS), Althusser detected a theoretical shortcoming in the very concept of Marxist-humanism.

In *For Marx*, Althusser identified two symptomatic failings of contemporary Marxist philosophy— humanism and historicism. His theoreticist critique was fueled by his innovative reading of Marx (which he explicitly theorized in *Reading Capital*.) Two things structure Althusser's reading: the autonomy of theory and Marx's supposed "epistemological break" with the "ideologies" of humanism and historicism. We can write these as four theses:

1. Marx's *theoretical* work deals with *objects of knowledge* necessary to diagnose and challenge capital.
2. The work of the "young" Marx (such as the *1844 Manuscripts*) is humanist and thus "ideological."
3. Marx's epistemological break begins with a conscious effort to root his analysis in an anti-idealist and anti-historicist framework as evidenced first in *The German Ideology*.
4. Marx founded a "science" whose master-text is *Capital* (there he *theoretically* renounces humanism).

Althusser's principal target in *For Marx* is "humanism." Khrushchev's call for a "return" to Marx's "humanism" was a politically expedient means to distance the Soviet Union from the Stalinist legacy or what Althusser with cool detachment termed the "Stalinian deviation." But this could not be corrected by a humanist reform of Marxism, argued Althusser, for Marx's mature work is not founded on the concept of the human but on that of class. *For Marx* calls for a return to Marx via an ideological critique of contemporary (read Soviet) Marxism. Marx and Marxism had to be distinguished. The latter, if it was to be philosophically reputable, would have to relinquish humanism as the mature Marx had. Stalin's politics of inhumanity had likewise to be distinguished from what Althusser termed Marx's "theoretical anti-humanism."

The thesis that Marx's mature work is theoretically anti-humanist may still strike readers as odd. The Marxist political project, after all, aims at the emancipation of humankind from exploitation and commodification. Althusser agreed. But he held that the political aims of Marxism rested on the *theoretical* work of the mature Marx. And this work is centered on the *object of capital* and its socializing processes. These processes create classes and structure class conflict. Marx's theory of capital, for Althusser, is a *social-scientific* theory and not a theory of *individuals*. And humanism is *the* ideology of individualism, but it is not a "scientific" theory of capital. To better understand "theoretical anti-humanism" requires that we better grasp Althusser's distinction between "science" and "ideology."

Science and Ideology

Althusser's thesis concerning the "epistemological break" between the works of the young Marx and that of *Capital* is structured by Althusser's distinction between Marx's young humanist "ideology" and his mature "science." Khrushchev's call for a return to Marx's humanism, from Althusser's perspective,

was a call to return to the ideological (young) work of Marx. What was needed, Althusser thought, was Marx's *science*.

In *For Marx*, Althusser writes: "in the couple 'humanism-socialism' there is a striking theoretical unevenness: in the framework of the Marxist conception, the concept 'socialism' is indeed a scientific concept, but the concept 'humanism' is no more than an *ideological* one."[4] Humanism, for Althusser, is a bourgeois concept that originated in the Enlightenment (bourgeois) political revolutions. Marx worked in this inherited framework, but that framework was abandoned in the writing of *Capital* because the individualist framework of Enlightenment liberalism proved incompatible with the structural and social conditions of industrial-scale capital. Althusser writes:

For the young Marx, "Man" was not just a cry denouncing poverty and slavery. It was the theoretical principle of his world outlook and of his practical attitude. The "Essence of Man" (whether freedom, reason or community) was the basis both for a rigorous theory of history and for a consistent political practice.[5]

The shedding of his humanist inheritance marked Marx's scientific work. This turn commenced Marx's "theoretical revolution." Althusser writes:

In 1845, Marx broke radically with every theory that based history and politics on the essence of man. This unique rupture contained three indissociable elements. (1) The formation of a theory of history and politics based on radically new concepts: the concepts of social formation, productive forces, relations of production, superstructure, ideologies, determination in the last instance by the economy, specific determination of the other levels, etc. (2) A radical critique of the *theoretical* pretensions of every philosophical humanism.

(3) The definition of humanism as *ideology*.[6]

Althusser's reading of Marx was an effort to *develop* Marx's science and to resist the Soviet recapitulation of liberal humanism under the cover of "Marxist philosophy." The theoretical challenge for Althusser was to construct a theory of reading Marx through Marx's *scientific* concepts without, however, falling into circular reasoning. The theoretical challenge: how to read Marx as a scientific Marxist without determining the reading in advance by recourse to inherited Marxist traditions of reading Marx? What was needed, Althusser argued, was to discover afresh what it means to be a Marxist in order to read Marx scientifically rather than ideologically.

Althusser's strident critique of "humanism" went hand-in-hand with his critique of "historicism." I will spend less time on this problem for it is less important to my overall effort in this text, but Althusser's critique of historicism should not be bypassed without notice.

Historicism, for Althusser, names the reduction of Marxist theory to the empirical data of history. Historicism in the Marxist context (as elsewhere) presupposes that phenomena (political, ideological, material, etc.) can be adequately understood by studying the history of such phenomena. Put shortly: historicism holds that a given phenomenon is its history. History=ontology. Althusser argued that historicism is also a form of ideology. This he names "empiricist ideology." The naivete assumed by the historicist who rejects "speculation" and "theory" in the name of historical facts is a form of theory nonetheless for "empiricism" *theoretically* reduces reality to what can be empirically verified. But what verification is – how to verify verification – or what constitutes "empirical reality" are not themselves empirical but *theoretical* problems. Althusser explicitly links his critique of the ideology of humanism with that of historicism. He writes in *Reading Capital*:

> I should like to suggest that, from a theoretical standpoint,
> Marxism is no more a historicism than it is a humanism; that
> in many respects both historicism and humanism depend
> on the same ideological problematic; and that, *theoretically
> speaking*, Marxism is, in a single movement and by virtue of
> the unique epistemological rupture which established it, an
> anti-humanism and an anti-historicism.[7]

The problem with the Marxist-historicist thesis, for Althusser,
is that it cannot account for how Marxism became a "science
of history" which enabled one to "think the conditions of
penetration into history."[8] Historicism denies the rupturing
force of historico-political practice. It reduces every historical
rupture to the historicity of continuity. Historicism speaks from
the assumed authority of history. But for Althusser, historicism
is a *theory of history*, albeit one that denies its own theoretical
foundations and for that reason perpetuates an *ideology of history*
under the cover of "historical facts."

Althusser's critique of historicism raised the ire of not a few
Marxist historians, most notably E.P. Thompson. In "The Poverty
of Theory," Thompson decries what he sees as Althusser's
philosophical elitism and his "willful and theoretically-crucial
confusion between 'empiricism' (that is philosophical positivism
and all its kin) and the empirical mode of intellectual practice."[9]
Thompson's indictment of Althusser's "idealism" is too quick by
half. But it does grasp a central thrust of Althusserianism: history
is treated by Althusser as "raw material" that must be refined by
theory so as to cleanse it of its historically-laden ideologies. It
is not enough to simply read Marx, according to Althusser, for
the reader has to also theoretically interrogate Marx's writings
and filter out their historically inherited ideological baggage
such as the young Marx's idealist (Hegelian) tendencies. This is
necessary, thinks Althusser, if what is desired is not merely to
read Marx dogmatically, but to *develop* his science. Toward this,

Thompson counters that Althusser's "raw material (object of knowledge) is an inert, pliant kind of stuff ...with neither inertia nor energies of its own, awaiting passively its manufacture into knowledge. It may contain gross ideological impurities, to be sure, but these may be purged in the alembic of theoretical practice."[10] Thompson's point is that Althusser's view of history denies it any agency or transformative power. These qualities, Thompson claims, are transferred to the agency embodied in the "laboratory of theory" where the "raw material" of history is refined into "knowledge" by a cadre of theorists. History, writes Thompson, is now to be "obediently processed by graduates and research assistants" within the "emplacements of École Normale Supériere."[11] Thompson ultimately accuses Althusser of countersigning a capitalist division of labor: the masses make history, but theorists process history and determine its political significance. The charge that Althusserianism divorced itself from history and class struggle is one that Althusser himself would later claim. But even in his post-theoreticist work, Althusser remained convinced that the relative autonomy of theoretical practice had to be preserved if Marxism was not to default into a dogmatic ideology.

Theory of Theory

Having established the principal targets of early Althusserianism – humanism and historicism –we should further specify what is unique about Althusserian theoretical practice. Its principal contribution was a theory of how to read Marx. This theory (and method) of reading Marx is termed "symptomatic reading" by Althusser. The axiom that underwrites this theory can be stated as: *Marx's work is symptomatically marked by historically specific ideological accretions; chief among these are classical political economy (Smith and Ricardo primarily) and idealist (Hegelian) philosophy.* Marx's mature work in *Capital*, by contrast we are told, broke with classical political economy and idealist philosophy. Marx's

science of history (historical materialism) is a fully constituted science, says Althusser, but his philosophy (dialectical materialism) remained incomplete and ideologically suspect.

Symptomatic reading (as theory and method) organizes Althusser's *Reading Capital*. This method and theory is governed by a Spinozist epistemological distinction between the "real" and the "object of knowledge." "Spinoza warned us," writes Althusser, "the *object* of knowledge or essence was in itself absolutely distinct and different from the *real object*, for to repeat his famous aphorism, the two objects must not be confused: the *idea* of the circle, which is the *object* of knowledge, must not be confused with the circle, which is the real object."[12]

The objects of knowledge comprising Marx's *Capital* – value, surplus-value, commodity fetishism, exchange, etc. – do not map onto the "real" of capitalist processes in a seamless one-to-one manner. The constellation of concepts that constitute Marx's *theory* in *Capital* are objects of knowledge – theoretical objects – and must be read as such. What has to be read then in any reading of *Capital*, Althusser argues, are firstly the epistemological conditions of its very theoretical conceptualization.

Althusser's chief problematic in *Reading Capital* can be stated as: how to explain Marx's "immense theoretical revolution" without reducing it to history (historicism) or to the singularity of Marx's subjectivity (humanism)? Althusser frames this epistemological problematic in a profound meditation on seeing, sight, and vision. He structures his question thus: what conditioned the possibility for Marx's *theoretical insights* in *Capital*?

Althusser's question turns on Marx's discovery of a glaring oversight in classical political economy. In *Capital*, Marx notes that the classical school of political economy confused and conflated the concepts "labor" and "laborer" in the classical labor value theory. Smith, for example, assumed that the value of labor, like any other commodity, was set fairly by the market. For

Smith, every "commodity is sold for precisely *what it is worth.*"[13] The classical school thought that prices revealed the worth of things. Thus, because labor was priced at the subsistence wage level, the classical school assumed that this price constituted the value of labor. What Marx saw, argues Althusser, is that the classical answer to the question concerning the value of labor was displaced by an answer referring to the value of the subsistence of the laborer. Put shortly, the classical theory of labor value is constructed around the wrong concept: laborer as opposed to labor. The classical theory of labor value is worse than contradictory; it is a non-sequitur. The political import of Marx's analysis is obvious, but worth noting nonetheless: workers should be paid a fair market price for their commodity (labor).

Althusser's theory needs to explain how Marx saw what classical political economy did not see: laborer and labor are distinct. This distinction was there all along, hiding in plain sight. So, Althusser's question is: how is it that Marx saw what was visible yet was invisible to classical political economy? What is the nature of this oversight immanent to classical labor value theory? Firstly, Althusser argues that the classical theorists did not see that they had *produced* a genuine question via an erroneous answer. They had not seen that they had theoretically produced an unanswered question: what is the value of labor? Thus, they firstly did not see that theory is *productive.* They held an idealist conception of theory as reality empirically reflected in thought. "What political economy does not see, writes Althusser, "is what it does."[14]

Althusser writes:

what classical political economy does not see, is not what it does not see, it is *what it sees.* ... The oversight, then, is not to see what one sees, the oversight no longer concerns the object, but *the sight* itself. The oversight is an oversight that

concerns *vision*: non-vision is therefore inside vision, it is a form of vision and hence has a necessary relationship with vision.[15]

The elision between "laborer" and "labor," and the silencing of the proper question as to the value of labor, were there to be seen and read in the text of classical theory all along. "Hence it is not Marx who says what the classical text does not say," writes Althusser, "it is not Marx who intervenes to impose from without on the classical text a discourse which reveals its silence – *it is the classical text itself which tells us that it is silent*: its silence is *its own words*."[16] Marx's theory sees the problem with the classical theory of labor value. It makes clear what is plainly visible: labor and laborer are not the same concept. But the insights and oversights at issue, for Althusser, have nothing to do with the persons of Smith, Ricardo, or Marx; the oversights and insights at issue are immanent to theoretical practice itself.

Classical political economy did not see that its theory produced, through its answer to the question of the value of labor, another "latent" question that Marx's theory makes us see: what is the value of labor? This latent question, once seen, does not merely transform the terrain of classical political economy. The horizon defined by this latent question structures a new field of theory entirely. Marx makes visible what had been visible, but unseen in the classical theory of labor value: labor and laborer are not the same concept. What conditions the possibility for the oversight of classical political economy, and Marx's insight, are the structural conditions of each theoretical field, and not the qualities or attributes of the theorists who labored in these fields. Allow me to quote Althusser at length on this point:

This opens a way to an understanding of the determination of the *visible* as visible, and conjointly, of the invisible as invisible, and of the organic link binding the invisible to the

visible. Any object or problem situated on the terrain and within the horizon, i.e., in the definite structured field of the theoretical problematic of a given theoretical discipline is visible. We must take these words literally. The sighting is thus no longer the act of an individual subject, endowed with the faculty of "vision" ... the sighting is the act of its structural conditions; it is the relation of immanent reflection between the field of the problematic and *its* objects and *its* problems. ... It is literally no longer the eye (the mind's eye) of a subject which sees what exists in the field determined by a theoretical problematic; it is this field itself which *sees itself* in the objects or problems it defines.[17]

This extraordinary passage is symptomatically marked by Althusser's own theoretical field, that of anti-humanism and anti-historicism. He resists any framing of Marx's theoretical revolution in historicist or in humanist terms. The first would reduce Marx's theory to history and thus negate the identity (and relative autonomy) of theory; the latter would reduce Marx's theory to Marx's psychology. What would go unaccounted for in either choice is the specificity of Marx's theoretical work. This tactic yields for the Althusserian theory of theory a strange quasi-agency. It is *theory* which "sees itself" in "the objects and problems *it* defines," as if between the field and its objects and problems, there is a silent dialogue or a silent exchange of gazes that produces purely intra-theoretical effects.

The effectivity of theory (intentional or not) is always productive if not transformative for Althusser. The key theoretical moment is the moment where what Althusser calls "raw material" – historical and ideological data – are processed, ordered, and finally transformed into objects of knowledge by theoretical practice. In *For Marx*, Althusser outlines a three stage process leading to theoretical knowledge as a sequence of three "generalities." These may be schematically presented in the

following way:

> Generality I: the "raw material" of facts, ideologies, and concepts.
>
> Generality II: a theoretical "problematic" is immanently determined by the intra-structural relations between the elements comprising Generality I; this is determinant of theoretical interrogations and resolutions to a given problematic; a productive process
>
> Generality III: the product, theory *qua* object of knowledge[18]

The entire process from Generality I through III takes place "in" thought and is therefore problematically tainted by inherited idealist ideologies all along the knowledge production process. The problem is how can theory be rendered "scientific" if thinking is itself always partially and inescapably idealist and thus ideological? Moreover, if the transformative processes of Generality II employs Marxist analytic tools, then how can the knowledge of Generality III be anything more than a self-confirming result of the presumed scientificity of Marxism? Gregory Elliott notes that this line of critique has been the most "powerful objection" to Althusserianism, namely, that "there is something inherently dogmatic and viciously circular in employing Marxist philosophy to guarantee the status of Marxist science."[19]

Althusser's response to this was effectively to affirm the historical necessity of this circularity. The history of knowledge practices underwent a revolution with the advent of Marx's "science of history" (historical materialism), argued Althusser, and this science spawned its own theory or philosophy (dialectical materialism). This affirmation of a methodologically "virtuous circle" (as Heidegger put it in another context) is saved from bald dogmatism by one caveat: dialectical materialism is incomplete and historical materialism must be researched

and further developed. Elliot writes: "What is the cogency of Althusser's 'indispensable circle'? According to him, Marxist philosophy existed de jure and was active de facto. Its practical content now had to be given theoretical form. In other words, it remained to be constituted."[20]

So, Marxist philosophy was to be found in Marx, but in an incomplete state in need of research and development in order to ground Marx's science. But this means that the ground of historical materialism is to be sought in thought; and this thus leaves Althusserianism open to the charge of idealism. How can useful Marxist knowledge be produced if the distinction between the "object of knowledge" and the "real object" is rigorously maintained as Althusser deems proper? How could there be anything like a materialist rapprochement between theory and the real if the Spinozist distinction between objects of knowledge and the real is the starting point? For whereas "the object of commonsense knowledge is 'given' by everyday experience," Elliott explains, "the object of science is 'constructed' by/in its conceptual system."[21] Althusser attempted to overcome the theory-reality split by unifying both under the heading of "practices." Althusser writes in *Reading Capital*:

> We regard an element of "knowledge," even in its most rudimentary forms and even though it is profoundly steeped in ideology, as always-already present in the earliest stages of practice, those that can be observed even in the subsistence practices of the most "primitive" societies. At the other extreme in the history of practices, we regard what is called *theory*, in its purest forms, those that seem to bring into play the powers of thought alone (e.g., mathematics or philosophy) … as a practice in the strict sense, as scientific or theoretical practice, itself divisible into several branches (the different sciences, mathematics, philosophy).[22]

Althusser's defense against the charge of idealism rests on his assertion that theory is a material "practice" and not an idealist or non-materialist phenomenon. Elliott writes:

> Althusser argued that the production of knowledge of real objects by the production of their adequate concepts was the result of a specific practice: theoretical practice. Althusser's first move was to insist that theory was not the (abstract/ spiritual) obverse of (concrete/material) practice, but itself exactly such a practice. Strictly speaking, there was no such thing as "practice in general," only "distinct practices."[23]

Althusser's theory of theory as theoretical practice – a specific and material practice – leads, however, into another circular argument. For if theoretical practice is a specific practice, then it should be possible to specify this specificity. But to specify the specificity of theoretical practice would itself require theorization. Thus, we find that to theorize theory as a practice requires the practice of theory itself.

In his remarkable contribution to *The Concept in Crisis*, Alain Badiou argues that "theory" is a symptomatically marked term signifying Althusser's stressed effort to achieve the "destruction of the dialectical pair theory-practice."[24] Badiou writes:

> It is clear when you say that theory is a practice, you destroy the *classical* relationship between theory and practice, but when you say that, as a sort of verbal definition of theory, theory is a theoretical practice, this is hardly very interesting or novel. So the point is thus to understand not the noun "theory," but the adjective "theoretical." And this passage is also in some sense materialist. It is materialist because it is founded by a radical assertion, which can be formulated as the statement: "Only practices exist."[25]

What I take from Badiou's reading of Althusser is that the assertion of theory as a materialist practice is secured by a "verbal definition," or what I would identify as a speech act. It is by calling "theory" a "materialist practice" that the "destruction of the theory-practice pair" is *performatively* achieved.

Theory is a materialist practice inasmuch as it is an inscriptive practice that operates within and through the material of language. Let me be clear: I am not suggesting that Althusser's theory of theory qua material practice is *only* rhetorical. My point is that it is importantly rhetorical and that theory is in fact an enunciative act within the space and material of language. And it is here that I identify an intersection between Althusser's manifest political theory and a latent aesthetic theory. Note that I am not arguing that there is a latent *theory of aesthetics* here, but rather that Althusser's theory of theory as theoretical practice is an aesthetic practice. Why? Because it is axiomatically structured by a verbal performance. Theory operates "in" thought and language through Generality I and II and what it produces in the form of knowledge (Generality III) is formulae, statements, theses. We could in fact schematize the production of the theory of theoretical practice in the following way:

Generality I: theoretical thought
Generality II: its transformation into a materialist problematic by verbal performance
Generality III: new object of knowledge is enunciated – theory is a material practice

The object of knowledge (theory) produced at the end of the above process is a materialist theory only because it was transformed from thought (idealism) to practice (materialist) precisely through the transformation of words. But what is interesting is that this transformation of theory by means of the materialist problematic is signified not by reference to rhetoric,

but to "vision." In the chapters to follow, I will argue that the envisioning of Althusserian theory – as an intra-theoretical theory of seeing – relies on two aesthetic strategies. One strategy is staging, a *theatrical* aesthetic informed by a modernist conception of theatre as the art of staging self-reflexivity; the other is a practice of *framing* informed by painting. What I aim to do, then, is to trace the latent aesthetic strategies that produced Althusser's theoreticist theory of theory. In doing so, I aim to demonstrate that Althusserianism was produced out of what Althusser might have called an "underground materialism of the encounter" between aesthetics and politics.

Chapter 3

Althusserian Aesthetics

Let me be clear about my intentions. I do not intend to explicate *Althusser's aesthetics*. Rather, my aim is to articulate the *aesthetics of Althusserianism* as a political theory. My reference points are taken from Althusser's essay on the theatre of Carlo Bertolazzi and his essay on the painting of Leonardo Cremonini. I have no intention of judging the validity of Althusser's claims concerning the work of either artist. What I will show is that each essay can be productively read as a study in theorizing in which the operation of theory is presented as, on the one hand, a figuration of theory as a self-reflexive drama of staging, and on the other, as an immanent pictorial production operationalized by framing the visibly invisible. These two points – the dramatic and the pictorial – will guide our reading and illuminate the latent aesthetic strategies through which Althusserian political theory unfolds.

Staging Theory

Carlo Bertolazzi's 1893 play, *El Nost Milan*, is the subject of Althusser's sole aesthetic reflection in the collection *For Marx*. "The Piccolo Theatre: Bertolazzi and Brecht (notes on a materialist theatre)" was Althusser's response to the play he saw staged by avant-garde director Giorgio Strehler in 1962 at The Piccolo Theatre. Strehler's direction, however, radically "condensed the original four acts into three" thus forcing a heightened sense of temporal discontinuity quite different than the play as written by Bertolazzi. [26] This temporal discontinuity plays a central role in Althusser's reading, as will become clear.

The play that Althusser saw was an example of "epic theatre" in the spirit of Bertolt Brecht. The play, set in Milan

in the 1890s, is structured by the modernist dramatic ethos of transparent artifice and self-reflexivity. The sentimentalism – or "melodrama" as the play was labelled by its critics – of *El Nost Milan* centers on the empty time of impoverished sub-proletarian life lived on the margins of a travelling fair that passes briefly through the gray town. Allow me to quote Althusser's description of the setting of the play, for it will enable us to begin to unfold the aesthetico-political intertwinement immanent to Althusserianism. Althusser writes:

> we find ourselves in an Italy unlike the Italy of our myths. And the people strolling at day's end from booth to booth, between the fortune-tellers, the circus and all the attractions of the fairground: unemployed, artisans, semi-beggars, girls on the look-out, old men and women on the watch for the halfpenny, soldiers on a spree, pickpockets chased by the cops … neither are these people the people of our myths, they are a sub-proletariat passing the time as best they can before supper (not for all of them) and rest.[27]

The spirit of Brechtian epic theatre is here given in condensed form: epic theatre punctures the illusions of representationalist theatre and those myths that accrue to historical places like Italy. The Italy of *El Nost Milan* is neither that Italy shrouded in the mythological veil of antiquity nor the equally mythological sentimental beauty of "simple" peasant ways of life. The Italy in which Strehler stages Bertolazzi's play is the unremarkable Italy of empty time in which the wretchedness of sub-proletarian life merely goes on. Even the fairground is a place voided of escapist illusions. The fair's existence only mirrors the sub-proletarianization of the town itself. The social and economic conditions of the entertainers and the entertained are too close to enable a convincing illusion of escape for either side. The very setting allegorizes the anti-illusionistic, non-

representationalist, anti-mythological aesthetic conditions of epic theatre.

Althusser's own description of the setting of *El Nost Milan* itself stages a presentation of the essential frameworks of Althusserianism as akin to epic theatre: anti-mythological, politically centered on class exploitation, anti-representationalist, and voided of the sentiment of humanist feeling. Althusserianism also stages the difference between theory and concrete existence in a way that parallels how epic theatre stages the staging of theatre, or the theatricality of theatrical production, which prevents theatre's disappearance into that which it stages.

The relation of stage to life in epic theatre, and of theory to practice in Althusserianism, is in both cases a *relation of non-relationality*. By this I do not mean that it is void of any relation, but rather that the relation between the two is contingent and indirect such that neither the surety of a positive or negative relation between the two is assured. Althusser continues: "A good thirty characters ... come and go in this empty space, waiting for who knows what, for something to happen, the show perhaps? – no, they stop at the doorway, waiting for something of some sort to happen in their lives, in which nothing happens. They wait."[28] The characters wait for they live in the empty time– that empty time epitomized by Beckett's *Waiting for Godot*. They wait for *nothing to happen* in their lives in which only nothing happens. And nothing is precisely what happens when something at last occurs, which for a moment, for a brief illusory moment, breaks the continuum of nothingness by what turns out to be, once again, nothing itself. A young girl, Nina, finds herself momentarily "transfixed by the lights of the circus" as she spies a clown performing, through a "rent in the canvas."[28] Through a tear in the circus tent, Nina, "with all her heart" watches the clown, but as she does, she is watched by the Togasso, the local pimp, who watches her with an eye to her

body and its profit potential.

Then the scene suddenly changes. Workers depart with the hoot of the factory whistle. Nina suddenly appears on stage "for no apparent reason," notes Althusser, "and with her the tragedy."[29] The clown is dead. The "rent" in the social fabric has closed over. Nothing has happened once again in this place of empty time where only nothing ever happens. The Togasso next appears and forcibly kisses Nina. She gives him what money she has. It is clear that she is now working as a prostitute. The ellipse in time obscures how long it has been since the day she spied the clown through the "rent in the canvas" and the empty present of sexual labor.

Nina's father eventually kills the Togasso. Before he goes to prison, he visits Nina to tell her that he killed to save her honor. But Nina rejects her father's morality. She now takes the world for what it is; a world conditioned by cash. Nina sees through the fabric of illusions. She has torn open the sentimental façade of moralism that dignifies poverty, but changes nothing. Althusser writes:

Nina turns on her father, on the illusions and lies he has fed her, on the myths which will kill him. But not her; for she is going to rescue herself, all alone, for that is the only way. She will leave this world of night and poverty for the other one, where pleasure and money reign. The Togasso was right. She will pay the price, she will sell herself, but she will be on the other side, on the side of freedom and truth.[30]

Althusser forges a dialectical reading of the play in the spirit of Brechtian drama. The tragedy of Nina's apparent resignation breaks her father's mythological spell over her; and not only the spell cast by her biological father, but, in a psychoanalytic register, the spell cast by the social and legal order of patriarchy – the law of the father. Her resignation is

an insurgent gesture against the mythologies of patriarchal moralism and honor. Nina has come to see what structures the world of domination: the law of exchange value, surplus labor extraction, exploitation. Nina's rupturing refusal of her father's morality breaks the melodramatic structure of the play and serves as a critique of the *content* of that moralizing ideology that sentimentalizes poverty as well as the theatrical *form* of melodramatic sentimentalism that glorifies it. It is this "internal dissociation" within the structure of the play that mobilizes its critique of melodrama and sentimental moralizing.[31] Althusser writes:

> The great confrontation at the end of the third act is more than a confrontation between Nina and her father, it is confrontation of a world without illusions with the wretched illusions of the "heart," it is the confrontation of the real world with the melodramatic world, the dramatic access to consciousness destroys the myths of melodrama, the very myths that Bertolazzi and Strehler are charged with. Those who make this charge could quite easily have found in the play the criticism they tried to address to it.[32]

The rupturing event of Nina's great refusal punctures the ideology of sentimental moralism and the aesthetic ideology of melodrama. Those critics who rejected the play as too sentimental failed to register the play's "internal dissociation" through which it self-reflexively stages melodrama and sentimentality precisely to expose them to critique. Importantly, Althusser spots this critical dimension in the immanent "structure" of the play's temporality. Althusser's "structuralism" is on display here insofar as it is the structure of the play and not the text that discloses its critical and resistant self-reflexive character. As Warren Montag observes, what is important for Althusser is not the content, but

the structure of the play, the work of dissociation and divergence that it carries on. *El Nost Milan* is not about reality, even the reality of Milan's sub-proletariat at the turn of the century; it is rather and most profoundly a critique of the dominant consciousness, melodramatic and moralizing, from the point of view of which, history must remain invisible.[33]

The rupture in the play's temporality signifies the rupturing force of a contingent event. Nina's appearance on the stage of self-reflexive insurgency occurs for "no apparent reason." Althusser's concern for the role of contingency in revolutionary historical processes is signaled across the three distinct phases of Althusserianism.

In *For Marx*, we have the theory of "overdetermination," which names the causal complexities that structure all historical "conjunctures." No one thing can be seen as determinant in a moment of genuine historical revolution. Extending Engels's concept of the illusory "last instance," the determination of what in the "last instance" causes revolution can never be determined for it is always plural and the precise balance of forces that condition it are always "overdetermined." Alas, for the empirically-minded historical materialist, Althusser notes, the "lonely hour of the 'last instance' never comes."[34]

The problematic of contingency is signaled again at the end of Althusser's career. During the very productive last years of his life (during which he also penned a memoir recounting what he could of the events that led to the death of his wife) Althusser was beginning to articulate a new theory entirely situated within the problematic of contingency. This would give rise to his truncated theory of "aleatory materialism." We could then read "The Piccolo" as an inchoate first start on a new materialist theory of history that would acknowledge the rupturing force of contingency that conditions and determines,

but always in an "overdetermined" manner, the course of revolution. The significance of "The Piccolo" to Althusser's work has been noted by Étienne Balibar who has noted that the essay is the "veritable geometrical and theoretical center" of *For Marx*, but it has "shamefully" received little attention "because it only concerns aesthetics and theater."[35] But I would suggest that this center is also the index of a profound linkage between aesthetics and politics in Althusserian theory. Let us explore this.

Althusser's reading of *El Nost Milan* turns on the temporal discontinuity between Nina's wistful gaze through the tear in the circus tent and her rejection of her father's morality. (Strehler's staging, as noted, lends the play this starkly discontinuous character, which is absent in Bertolazzi's original text.) This difference between the text as written and Strehler's staging of the play *makes a difference* analogous to the work which theory does in staging concrete reality as concepts.

Althusserianism draws theory (or philosophy) and theater into a proximity that underscores the productive work accomplished by the self-reflexive aesthetics of staging. Althusserian theory would then be a kind of theater – a modernist, Brechtian theater – which makes visible and continually highlights the conditions of its productivity in a self-conscious and self-reflexive modality. This self-reflexive obsessiveness, centered on the conditions and effects of its own productivity, is a meta-meditation on the productivity of production itself. And this self-reflexive theater of production situates Althusserianism squarely within a Marxist frame.

Lest I be accused of stating the obvious – Althusserianism is Marxist – let me clarify my point. I am locating Althusser's Marxism not (only) at the level of his explicit propositions, but deeply at the aesthetic level of its mode of theoretical articulation. Althusser himself noted this intersection of theory and theatre in an unfinished essay on Brecht and Marx

written in 1968. There he avers that "theater and philosophy are fundamentally determined by politics but devote all their efforts to deny this determination in order to appear to have escaped politics."[36]

We could say, that, for Althusser, bourgeois philosophy like bourgeois theater denies its political conditioning in conformity with liberal ideology that presumes that politics, philosophy, and art occupy discrete disciplinary and cultural domains. Critics on the Left and the Right have consistently demonstrated that the apolitical conception of "culture" is the signature of political liberalism itself. The depoliticized character of liberal culture is simply liberalism's political ideology in cultural action. The "politicization" of culture in the plays of Brecht and the philosophy of Marx is not a "re-politicization" of theater or philosophy. It is rather the enactment of drama and philosophy voided of the depoliticized ideology of liberalism. "Brecht and Marx both in their own way," writes Althusser, "seek to bring about a displacement, a dislocation in theater and philosophy that makes them speak about precisely what they deny: their relations to politics."[37] It is in the staging of production that Althusserianism is Marxist and not only at the level of its manifest discourse whose Marxist provenance has been contested by Althusser's many critics. Althusserianism is aesthetically (if not theoretically) Marxist.

Framing Theory

I want to further explore Althusser's aesthetics of theory (not his theory of aesthetics) by turning to his essay on the painting of Leonardo Cremonini. My wife spotted the newest edition of Althusser's *Lenin and Philosophy*, which contains his essay on Cremonini, and she noted that it was a "strange" image for the cover. The image is *Court Circuits* painted by Cremonini around 1977. It is a strange image. The painting sets a collection of abstract, but recognizably figurative objects, in a domestic

space: nursery, crib, baby, chairs, arms, outlet, doorframe, hall, staircase, banister, window, adult (mother?). It is at once highly abstract and completely figurative. The two are not really opposites. The popular use of the term "abstract" is often used to refer to paintings that are technically speaking "non-representational."

Cremonini mobilizes abstraction in order to situate figurative and formalist aesthetics within a creative dialectic. We see and recognize objects, but in a spatial and compositional ordering that resists easy attribution or identification. The title of Althusser's essay on Cremonini is telling – "Cremonini, Painter of the Abstract." Cremonini, according to Althusser, is not simply an abstract painter, but a *painter of the abstract*. Althusser writes that Cremonini's

> strength as a figurative painter lies in the fact that he does not "paint" "objects" ... nor "places..." nor "times" or "moments...." Cremonini "paints" the *relations* which bind the objects, places and times. Cremonini is a *painter of abstraction*. Not an abstract painter, "painting" an absent, pure possibility in a new form and matter, but a painter of the real *abstract*, "painting" ... real relations (as relations they are necessarily *abstract*) between "men" and their "things," or rather, to give the term its stronger sense, between "things" and *their* "men."[38]

Althusser reads the discontinuous spaces that bind objects ("things") and subjects ("men") in Cremonini's paintings as a set of "relations" which, precisely because they are relations, are abstract. Relations are abstract insofar as they are not empirical in the way that objects are. Relations are an abstract set of connections (social, political, cultural, historical) that bind subjects and objects. The abstraction of Cremonini's work thus lies not in its style, according to Althusser, but in its subject

– relations. Althusser accents his reading in a distinctly Marxist tone in concluding that the relations at issue in Cremonini's work are not merely those between men and their things, but between things and their men. Recall that Marx in *Capital* argues that the phenomenon he names "commodity fetishism" consists in seeing social relations between subjects as commodified relations between things. We see people as objects of value. The fetish for the commodity-form governs the relations between subjects who are then seen as a derivative function of exchange relations. (The clearest ideological expression of this condition is the statement: "I value you.") Althusser writes:

Cremonini thus "paints" ... the history of men as a history *marked*, as early as the first childhood games, and even in the anonymity of faces (of children, women, and men), by the *abstraction* of their sites, spaces, objects, i.e. "in the last instance" by the *real abstraction* which determines and sums up these first abstractions: the relations which constitute their living conditions.[39]

The "real abstraction" made visible in Cremonini's paintings is, to be precise, an absence made present or an invisibility made visible without, however, being represented or presented.

Althusser's essay on Cremonini is in large part a riposte to Soviet-style "socialist realism." Althusser positions Cremonini's art against the neo-classicizing impulse of Soviet art with its endlessly repeated motifs: heroic bodies of laborers, leaders, and soldiers. True socialist realism, for Althusser, must make us see the invisible social relations that constitute "living conditions," but in such a way that it makes these *invisible relations seeable as invisibilities*. Althusser's interest in Cremonini's work, notes Montag, stemmed from his "increasing distaste for realist art (whether socialist or merely social realism)" and "his growing conviction that realism was based on the extremely naïve

notion that reality lay before it waiting to be represented."[40] In other words, Cremonini shows that social reality, consisting of the "real abstraction" of relations, is not visible as empirical objects are, but is every bit as real, and in fact is the structuring element that binds objects and "their" subjects. Relations are the fabric of the real. Cremonini paints the "visible connections that depict by their disposition, the *determinate absence* which governs them."[41] Once again, as in Althusser's discussion of *El Nost Milan*, the problematic of "structure" appears on his theoretical stage. Althusser writes:

> The structure which controls the concrete existence of men, i.e. which informs the lived ideology of the relations between men and objects and between objects and men, this structure *as a structure*, can never be depicted by its presence, *in person*, positively, in relief, but only by traces and effects, negatively, by indices of absence.[42]

Cremonini does not make visible the structure of social relations. These relations can never be made visible or present "in person" for they do not exist in visible and present forms. They can only be seen negatively by "indices of absence." What Cremonini shows us is the *invisibility of social relations*. What he critically makes us see are the invisibilities and absences that structure "living conditions."

Cremonini's paintings of the abstract and *El Nost Milan* are theoretically linked. Althusser prizes each for the way in which they *make us see those invisibilities* called "social relations." It is the invisible ordering of the relations between objects and subjects that Cremonini make us *see as social invisibilities*; just as *El Nost Milan*, in its way, stages the social invisibility of moral sentiment that ideologically structures Nina's life.

Invisibilities

I want to suggest that Althusser's prizing of the critical aesthetic through which what I call "invisibilities," are seen as invisible fundamental structures in his theory of theory. As noted, in *Reading Capital*, Althusser argues that Marx's theoretical method enables readers to see the "blanks" that structure the classical answer to the question concerning the value of labor, which are precisely those invisibilities concerning *what in fact is being evaluated* in the theory of labor value. Althusser writes:

> The original question as the classical economic text formulated it: what is the value of labor? Reduced to the content that can be rigorously defended in the text where classical economics produced it, the answer should be written as follows: "The value of labor (...) is equal to the value of the subsistence goods necessary for the maintenance and reproduction of labor (...)." There are two *blanks*, two absences in the text of the answer. Thus Marx makes us *see* blanks in the text of classical economics' answer.[43]

Marx makes us *see* blanks, absences, invisibilities in the classical answer to the question concerning the value of labor. The criticality of Marx's work, for Althusser, lies first in making us see these *blanks* as the paintings of Cremonini and *El Nost Milan* frame and stage the structural invisibilities of social relations.

However, while Althusser credits Marx with enabling readers to see the blanks in classical political economy, the name of "Marx" is displaced by the name of "theory." Althusser writes: "it is not Marx who says what the classical text does not say, it is not Marx who intervenes to impose from without on the classical text a discourse which reveals its silence – *it is the classical text which tells us that it is silent*: its silence is *its own words*."[44] Four pages later, Althusser will return to the problematic of seeing blanks or of seeing invisibilities. All

things *in theory* are visible even if only as invisibilities or blanks in a "definite structured field of the theoretical problematic of a given theoretical discipline [that] is visible."[45] All things are visible (even if only as invisibilities) within a structured theoretical field. This means that theoretical visibility is not dependent on an "individual subject" who sees; the sighting at issue is the immanently intra-theoretical effects of a given problematic.[46] Theoretical sighting "is the relation of immanent reflection between the field of the problematic and *its* objects and *its* problems."[47] And here, again, is the critical passage cited earlier, but which now can be read in light of Althusser's prizing of the aesthetico-theoretical mode of staging and framing invisibilities: "it is this field which *sees itself* in the objects and problems it defines."[48]

In Althusser's "A Letter on Art," published in 1966, he further indexes this aesthetic of invisibility that structures his theory of theory. There he emphatically distinguishes art from knowledge, which is for him the domain of theoretical practice. But this line between theory *qua* knowledge and art symptomatically wavers. "What art makes us *see*, and therefore gives to us in the form of *'seeing,' 'perceiving,' and 'feeling' (which is not the form of knowing)*," writes Althusser, "is the *ideology* from which it is born."[49] Art presents ideology's absence or, put otherwise, it makes visible the invisibility of ideology. Art makes us see the ideological invisibilities *qua* invisibilities that structure living conditions. But, for Althusser, this "seeing" is *not* knowing. What art presents is not theoretical knowledge. Art can "make us 'perceive' (but not know)," writes Althusser; art can only *present* ideology "*from the inside,* by an internal distance."[50] Art and "scientific" theory (read Marxist theory) allows one to "see" ideology. But it is "science" *qua* theoretical practice alone that renders what is seen to be invisible as "form of knowledge."[51]

Aesthetics of Aesthetics

We are then dealing with two forms by which the invisibility of ideology can be framed: as perception in art and as knowledge in Marxist science. But this clever distinction is precisely what is seen to fail in Althusser's reading of *El Nost Milan* and Cremonini's painting.

El Nost Milan self-reflexively stages a critique of sentimental moralism and makes us see the invisible power of social norms; Cremonini frames the abstract and invisible social relations that bind subjects and *their* objects. What the play and the paintings show are the hidden social relations and norms that structure living conditions.

Althusser's claim that art's showing or seeing of blanks, invisibilities, or absences is not knowledge is refuted by his own theory of theory as precisely a *field of visibility* in which even the invisible is seen as such – *seen as invisible*. If theory is a field of visibility, or the staging of a theatre of the visible, to put the matter more directly, then why is the work of framing and staging the visibility of invisible ideology via art not already an immanent form of knowledge? Has Althusser as a theorist seen something other than what is already visible in the work of painting and drama? If so, how can the Althusserian theory of theory, as a field of sighting irreducible to a "subject endowed with vision," be rigorously maintained? I suggest that it cannot.

What is visible in Althusser's "A Letter on Art" is a schematic division of labor. *Artists make and theorists know.* The ideology that structures this is capitalist to the core. This ideological schema (given in the form of a defense of the necessity of a theoretical "knowledge of art") reproduces the classical distinction between manual and intellectual labor. Artists make and theorists think. Put simply, Althusserian theory presents a division between aesthetics and epistemology. The Althusserian theory of theory thus frames or stages a division of labor that its very operation of framing and staging cancels. For, insofar

as the work of aesthetics is at bottom the art of presentation, then a "theory of art" is a presentation of a presentation given in the form of "knowledge." The theory of art is a presentation of a presentation: an aesthetics of aesthetics.[52] Theory is a presentational device – an aesthetic form – an art itself.

Chapter 4

A Lesson in Aesthetics and Politics

This chapter looks at the legacy of Althusserianism as reflected in the aesthetic and political theory of two of Althusser's brightest students – Jacques Rancière and Pierre Macherey – each of which contributed essays to *Reading Capital*. Rancière, with whom we will begin, famously rebelled against Althusser's teaching. His remarkable critique, *Althusser's Lesson*, of 1974 charged his former teacher with reproducing the capitalist distinction between intellectual and manual labor: theorists think and workers produce the raw material of history and revolution. Macherey remained far more sympathetic to Althusserianism. His text, *A Theory of Literary Production* of 1966, sought to apply Althusserian theory to literary criticism. What I aim to show is that Rancière and Macherey produced a new reading of Althusserianism as a body of aesthetico-political theory. This reading reveals only what was already there to be seen within the field of visibility determined by the definite structured problematic of Althusserianism.

Althusser's Lesson

In his 2010 preface to the re-edition of *Althusser's Lesson*, Rancière recounts the political and historical context which produced his critique of Althusser. That context was Paris in May 1968. The "spontaneous" uprising in May by students and workers was neither led nor endorsed by the French Communist Party (PCF). The party condemned the uprisings as misguided "spontaneity." With much ambivalence, Althusser accepted the PCF's judgment and encouraged his students to return to school to *theoretically* prepare for a revolutionary future yet to come. For Rancière, this decision by the party, countersigned by Althusser, amounted to

a theoretical and political counterrevolutionary gesture.

Rancière's text targets the post-May reassertion of liberal order legitimated by the political authority of the PCF and the intellectual authority vested in Althusser. The idea that students and workers could not (or should not) revolt without the guidance of theory and party leadership presupposed that they had neither the political nor the theoretical intelligence to carry it out. "My book declared war on the theory of the inequality of intelligences," writes Rancière, by holding "that all revolutionary thought must be founded on the inverse presupposition, that of the capacity of the dominated."[53]

Rancière's critique of Althusserianism centers on the manner by which it latently reproduces the capitalist division between mental and manual labor. Rancière argues that Althusser conceptualizes workers as beings entirely immersed in the world of *natural* needs; the need for food and shelter which they secure by working raw materials into commodities in exchange for wages. But it is different for theorists. They work on the "raw material" of history furnished by workers and transform it into theory – into *knowledge*. Rancière writes:

Althusser needs the opposition between the "simplicity" of nature and the "complexity" of history: production is the business of workers, whereas history is too complex an affair for them, one they must entrust to the care of specialists from the Party and from Theory. The masses produce – and so they must, otherwise we scholars would have to do it. In that predicament, how could we defend "our right and duty to know." ... The masses should wait for the "theses" that specialists in Marxism work out for their benefit. Roll up your sleeves and transform nature; for history, though, you must call on us.[54]

The tone of lines like these are not only polemical; they are

personal. It is the tone of a student alienated and betrayed by his education and by a teacher he once revered. Althusserianism, for Rancière, amounts to the use of Marxist "theory" to justify the continuance of the political order under the cover of theoretical radicalism. The intelligentsia must lead the workers, who, alas, Althusserianism holds to be "forever separated" from the history they make "by the thickness of the 'dominant ideology,' by the stories the bourgeoisie is constantly feeding them, and that they, stupid as they are, would forever be eating up were it not for the fact that we theorists are there."[55] Rancière's verdict: Althusserianism affirms that everyone is in their rightful place – workers are at work, theorists are in the classrooms, politicians are in the parties. Althusserianism thus cannot furnish weapons for revolution for it immanently demands social stasis.

Rancière's reading of Althusserianism zeroes in on a similar pattern of elitism that E.P. Thompson analyzes in "The Poverty of Theory." For both Thompson and Rancière, Althusser's theory of theory masks a political and academic conservatism that arrogates leadership of Marxist thought to an elite cadre of theoreticians. Althusserianism may produce new objects of Marxist knowledge – such as conjuncture, overdetermination, or the last instance (which we explore below) – but it does not instate an "epistemological break" with the capitalist conceptualization concerning the division of labor under capital.

Althusser's Lesson marked Rancière's definitive break with Althusserianism and the start of his work on the politics of aesthetics. Rancière's post-Althusserian work has examined not only art, but more importantly, the aesthetic dimension of politics and education. Rancière's interlinked aesthetical and political concerns are effectively synthesized in *The Politics of Aesthetics* and *Dissensus*.

The Politics of Aesthetics is concerned with the relation between politics and aesthetics not only in terms of the relation between political and artistic practices, but with what, for Rancière, is

the *fundamentally aesthetic condition of political practice.* Rancière argues schematically that there is an antagonism between "politics" and what he calls the "police." Politics, for Rancière, is an emancipatory rupturing of the ordering of space, visibility, and speech maintained by the repressive apparatus of state, social, political, and normative power or simply the forces embodied in the "police." Emancipatory politics – genuine democracy – manifests in making time for, giving space to, making visible, and making audible voices and bodies excluded from power. It is the process and practice that violates the "commonsense" order of what can be seen and said. Politics then is an intervention in what Rancière terms the "distribution of the sensible" for it redistributes the order of space, speech, and sight in the political field. Politics reapportions what is common to political sensibility. Rancière writes:

> The distribution of the sensible reveals who can have a share in what is common to the community based on what they do and on the time and space in which this activity is performed. Having a particular "occupation" thereby determines the ability or inability to take charge of what is common to the community; it defines what is visible or not in a common space. ... There is thus an "aesthetics" at the core of politics.[56]

Participation in a community is structured by what position one occupies in the order of commonsense or the shared distribution of the sensible that normalizes the arrangement of spaces, sights, and voices within the community's political field. One's *occupation* – the place assigned to a subject in the sensible sphere – determines if one has a share or not in what is common to the instituted community. Political rupture, the practice of emancipatory politics, violates the governing "commonsense" of an established and "policed" community. It is why, as Rancière argues, protest is so often heard as mere "noise" by those in

power. Protesting bodies and voices – the visibility and audibility of politics *qua* emancipation – does not make sense according to what a policed community holds to be commonsense. Witness the familiar litany of terms of abuse voiced against those who refuse to *mind their place*: dreamers, idealists, utopians, fools, impractical, impossible, immature, and so on. It is in this sense that Althusserianism, for Rancière, amounts to a theory not of politics, but rather the police, for it legitimates the commonsense order that keeps everyone occupied in doing their assigned tasks. Workers work, theorists think, politicians politicize: Althusserian theory legitimizes the policing of the reigning distribution of the sensible under capital.

There is then an open question: what kind of theory would be a theory of politics (*qua* emancipation) and not a theoretical legitimation of the "police?" What would theory have to produce to force in thought a rupture with the commonsense of a policed community? Rancière offers a set of provisional starting points in his "Ten Theses on Politics" in *Dissensus*. Thesis three is of particular importance for present purposes:

Thesis 3: Politics is a specific break with the logic of the *arkhê*. It does not simply presuppose a break with the "normal" distributions of positions that defines who exercises power and who is subject to it. It also requires a break with the idea that there exists dispositions "specific" to these positions.[57]

Political theory (if not political practice) must be an anarchic force of rupture (which is not the same thing as the political theory and tradition established under the name "anarchy"). And there is something in the very tone of "theses" – a style that Rancière learned from Althusser – that fits the bill. A thesis is pointed and forceful and it is the start of something – a first cut. But by virtue of the provisional nature of this first cut it is voided of the surety of a teaching, a philosophy, an educative imperative – an

order. Political theory must then adopt a certain style of address – a certain aesthetic – that will disallow the reproduction of a policed order of thought governed by the *arkhê* of a structured and determined tradition of thought and the hierarchic social structures that validate and reproduce it through formal and informal educational apparatuses. Would then political theory be a theory and practice of a certain mode of speech and text, a political style of address? It is to the question of the stylistic politics of literature and theory that Pierre Macherey turned and to which we in turn now turn to follow out this line of inquiry.

A Theory of Literary Production

Pierre Macherey's 1966 text, *A Theory of Literary Production*, is arguably the most faithful "application" of Althusserian theory to the study of literature. Perhaps it would be more accurate to say, however, that Macherey recognized the fundamentally literary-critical character of Althusser's reading practice. (Indeed, one way to read *Reading Capital* is to read it as literary theory.) Althusser's stress on the problematic of reading paralleled developments in postwar literary theory, especially deconstruction, and most especially the deconstructive theory of Paul de Man, for whom the question of what it means to "read" was critically crucial.

Macherey's intervention begins by positing that criticism is a field "without an object."[58] Put simply, the *field* or "domain" of criticism are the texts designated "literature," but the *object* of criticism is not literature. A theoretical-critical text on a novel by Balzac, for example, is obviously not the same as the novel. But what is the difference? What is the object called "criticism;" by what trait (or traits) can it be distinguished from all other modes of textual production? There is a dialectical dynamic at work here: if the object of criticism can be determined, then the identity of "literature" will also be necessarily determined.

Macherey recognized that the question of literature is always

already a theoretical question concerning the identity of the object called "criticism." But I would add that given that the question of the identity of literature and criticism can only be answered *theoretically*, then what is really at issue here is the question: *what is theory?* And it is to this question that Macherey reproduces a perfectly Althusserian line. "Theoretical practice," if it is to produce a "rigorous knowledge must beware of all forms of empiricism."[59] Theoretical practice is non-empirical for Macherey, as for Althusser. Macherey does not think that a "rigorous knowledge" of literature lies in wait to be discovered in literary texts, but must be *produced*. Macherey writes:

> the objects of any rational investigation have no prior existence but are thought into being. The object does not pose before the interrogating eye, for thought is not the passive perception of a general disposition, as though the object should offer to share itself, like an open fruit. ... The act of knowing is not like listening to a discourse already constituted, a mere fiction which we have simply to translate. It is rather the elaboration of a new discourse, the articulation of a silence.[60]

Macherey's theory of theory affirms Althusserianism: theory is the production of an *object of knowledge* determined by a "structured field." The "object" called "criticism" is produced through theoretical production. This object is entirely different than the object called "literature." The difference lies in the nature of materials. Literature is pragmatically defined as raw material for a theory of literature. A theory of literature does not lie in wait in literature; it must be produced by theoretical practice. Macherey's theory of theory (like that of Althusser's) is likewise vulnerable to the charge of idealism. Macherey writes:

> If we are to preserve the value and potency of thought, we must no longer think of it as a provisional stratagem or artifice,

an intermediary or means through which we approach truth and reality in order to take possession of them. We must, in other words, restore it to its rightful autonomy. ... We must acknowledge its capacity to generate novelty, to actively transform its initial data. Thought is not an implement but a task.[61]

We see here that Macherey identifies thought as a doing, a "task," which generates a novel object called "criticism," and by virtue of this operation, theory is restored to "its rightful autonomy." Theory produces criticism. The autonomy of theoretical practice is axiomatically claimed, and by the axiomatic arrogation of this right, the question of literature becomes a *critical* question that it falls to theory to produce. What we have then, very much like Althusserianism, is a theory that affirms that everything is already in its rightful place. The texts that writers produce is the "raw material" – Generality I in Althusser's schema – that is worked into a theory, Generality II, and which finally produces a "rigorous knowledge," Generality III, of literature. Writers produce texts, but *theorists know what literature is.* The distinction between literature and criticism, for Macherey, is that between raw material (thing) and knowledge (thought). Thought once again is the grounding for Macherey's materialist theory of "literary production."

We can see, through the lenses of Macherey's affirmation and Rancière's critique, that the philosophical limitation of Althusserianism is its idealism while its political limitation is that it theoretically affirms the capitalist division of labor between mental and manual labor or between making and thinking or between theory and practice. Rancière and Macherey both, in different ways, articulate a struggle with the politics of theory. Two linked questions are immanent to their work: what should political theory say and how should it say it? The question of political theory and the style of political theory return us to the

aesthetico-theoretical problematic opened by Althusserianism. What place should the occupation of "theorist" occupy in the *arkhê* that orders the distribution of the sensible if the theorist's task is not to reaffirm and reproduce the policing of "normal" places and reify the concept of the social *arkhê* itself? I want to conclude this chapter by turning to the non-philosophy of François Laruelle in general, and to his "non-Marxist" perspective in particular, as I believe it offers a way forward beyond the problematic of Althusserianism. Laruelle operationalizes a practice of theory as an aesthetic practice he calls "philo-fiction," which constructs a perspective that imaginatively disposes of the problem of "dispositions" specific to the places and times of the politics of the police and the *arkhê* that names and reproduces it. I will then conclude by placing Althusserianism in an invented genealogy stretching from Korsch through Althusser and his students to Laruelle as the search for an aesthetic form capable of surpassing the theory-practice dialectic.

Non-Philosophy and Non-Marxism

It is to the work of a pioneering generation of theorists, including Katerina Kolozova, Rocco Gangle, John O' Maoilearca, Anthony Paul Smith, Alexander R. Galloway, and others that the innovative work of François Laruelle is at last being read with interest and criticality. It is necessary to briefly outline the contours of Laruelle's theoretical project so as to show how his conception of "non-Marxism" can serve as a corrective to the problematic splitting of the theory-practice question in Althusserian and post-Althusserian theory.

Laruelle hails from the same generation as Macherey, Rancière, and so many others of the post-Althusserian moment. But his significance in what came to be called "French Theory" (a largely North American invention) went largely unrecognized until recently. Part of the reason for his marginalization owes

to the fact that Laruelle's project is so idiosyncratic that it was difficult to assimilate into the patterns of French postwar theory even while much of his work has directly or indirectly engaged with those very patterns. Laruelle calls his work "non-philosophy" or "non-standard philosophy." While the latter term is less misleading, the former has been more widely adopted and used. So what in brief, is non-philosophy?

Non-philosophy is firstly *not* a negation of philosophy (or theory) as such. Rather, non-philosophy is a way of doing philosophy very differently. What Laruelle calls "standard philosophy" is governed by its desire and demand to decide the nature of "the Real." Standard philosophy's identity as such is tied to this operation according to Laruelle. From Plato's Forms, to Hegel's Spirit, to Heidegger's Being, to Marx's class struggle, and so on; these are so many "decisions" on the nature of the Real. It is this decision, what Laruelle names "Philosophical Decision," which standardizes philosophical practice.

Non-philosophy rejects (at least in principle) the operation of Philosophical Decision. Perhaps, it would be better to say, however, that it affirms a practice of deciding philosophy otherwise. Non-philosophy axiomatically brackets out the Real from any decision on the grounds that no decision (philosophical or otherwise) is sufficient to make such a decision. Non-philosophy thus rejects what Laruelle calls the "Principle of Sufficient Philosophy." What divides standard philosophies – their decisions on the Real – obscures what actually unifies them. According to Laruelle, all philosophies are unified by their shared epistemic insufficiency to decide the Real.

What becomes of philosophy in light of non-philosophy? It is seen as so much "raw material" for non-standard philosophical thought. Laruelle's method is to "clone" (his term) the "raw material" of philosophy and fashion out of it texts that *look* like philosophies, but which operate in non-standard (non-decisionist) ways. Whereas Althusserianism works the

"raw material" of history (of politics, art, etc.) into theory (knowledge), non-philosophy works on philosophy as if it were "raw material" to be transformed not into knowledge, but into a thinking otherwise than that sanctioned as knowledge according to standard philosophy. Let us now turn to Laruelle's "non-Marxist" work as that is most important for present purposes.

The theory of non-Marxism is given its most extended and rigorous treatment in Laruelle's *Introduction to Non-Marxism*. The text is not easy. The rhetoric is anodyne and the syntax is grating. But these stylistic peculiarities are not without purpose; for it is as much at the level of style as substance that non-philosophy operates. Style is a kind of operator of distinction for non-philosophy.

The style of non-philosophy is ever in the service of what Laruelle terms "vision-in-One." This way of theoretical seeing (and saying) affirms that "in-the-last-instance" the Real is immanent and determinant of all things, including thought. Laruelle's entire project is marked by an effort to *think the radical immanence of the Real immanently*. Laruelle seeks a style and "force of thought" that rigorously jettisons that prepositional favorite of standard philosophy: there is for him no thought *on* the Real for there is no "place" external to the immanence of the Real from which such a thought could be made. For Laruelle, there is only ever a thinking "in" the Real – a thinking immanent to its fabric. But this "in" can never be placed "in" relation to the Real for this would require knowing the limits of the Real. But these, for Laruelle, are what cannot be thought, for to think the limits of the Real would presume that philosophy is sufficient to know the Real as a totality.

Laruelle's non-philosophical work has resulted in a set of concepts and projects voided of the decisionist bearings of standard philosophy. In his project on Marxism, Laruelle has sought to "clone" Marxism, but mutate its hallowed ontological grounds and epistemological wagers. From Laruelle's radically

immanent perspective, his "vision-in-One," Marxism is voided of the base-superstructure schema. It is not that there is a "real" productive base and a cultural superstructure, but rather that there is only the real base of the Real (as unknowable) and this Real includes all the raw material of production as well as all the Marxist (materialist) philosophies that seek to frame and know it. To put the matter in the terms of the famed "coat" that Marx used to describe the modes of production and exchange that structure capitalist relations, Laruelle would put the matter thus: the coat, exchange, *and the philosophy* that thinks these relations are all part and parcel of the Real. Laruelle thus displaces the two-story architectonic of orthodox Marxism with what Deleuze might have recognized as a "plane of consistency." But, and this is key, if the Real is the immanence of which thought is part, then, Laruelle concludes, there is only a *relation of non-relation between thought and the Real*.

The Real does not "relate" *to* thought for the former and the latter are part of the One that is the Real. There is no relation between things in the Real for the Real is the immanence that precisely is all relations. There is no "to" to which the Real relates for it is everything and determinant of everything in the last instance. Thus, it is not that there is a Real that Marxism thinks. Rather, for Laruelle, there is a Real that includes what can be thought under the sign of "Marxism." Laruelle gives up then on reforming Marxism. He instead works on the philosophy of Marxism as a raw material for a thinking otherwise than deciding on the Real in an effort to think anew the emancipatory potency of Marxist thought. But this begins for Laruelle by emancipating thought from the ideological dogma of Marxist philosophy. Laruelle situates this task in light of the supposed "failure" of Marxist politics. Thus, he poses in *Introduction to Non-Marxism* a question cloned from Lenin's thought:

With the supposed failure of Marxism the question "as

a Marxist, or even a communist, what is to be done?" has taken on a new dimension: "What is to be done with Marxism itself?" ... More than ever, there is a strong temptation to inject "Marxism" with philosophy and the human sciences, with this doctrine or that scientific supplement, in order to make Marxism intelligible or more concrete, more "acceptable," adapted to current problems or what we believe to be the conjuncture. But do we want to save the sinking ship, to inherit its wreckage? Why not the opposite solution (if it exists) which would consist in taking Marxism out of the most philosophical of premises and define it by its kernel which is irreducible and foreign to philosophy? How can one, for example, be faithful to the specific immanence of its project?[62]

What is this "kernel" of Marxism that is irreducibly "foreign to philosophy?" The kernel at issue is none other than the immanence of the Real. Marx, argues Laruelle, was at his best when he tried to think the immanent conditions of human suffering under capital. It is the case, for Laruelle, that when Marx is at his *least philosophical and least abstract* – his least mature in Althusser's sense – that he is most faithful to the emancipatory potential of his own thought. Non-Marxism is firstly faithful not to the philosophy of capital, but to what is real and concrete, namely its victims.

Laruelle's anti-Althusserianism is most visible in his insistence on the category of "the human" as a necessary point of address in the articulation of radical politics. But this "human" for Laruelle is not "the human" of humanism (or anti-humanism, posthumanism, etc.), but the "real" human irreducible to philosophical abstractions. There is then an important intersection between the human and the Real in non-philosophy: both are irreducible to philosophical abstraction and in this sense beyond the grasp of standard philosophy in the last instance.

In *Towards a Radical Metaphysics of Socialism: Marx and Laruelle*, Katerina Kolozova argues that non-philosophy's rejection of standard philosophy, theory, or speculative practice does not lead Laruelle (any more than Marx) into dogmatic positivism. Similar to "Marx's project of creating a science of the political-economic exploitation of human labor," writes Kolozova, "the non-philosophical idea of 'the science of the human' is not positivist. Marx is opposed to philosophical materialisms of all sorts, and pleads for one grounded in the 'real interests' of humanity."[63] This admittedly strong reading of Marx's work presumes that in the final analysis Marx opposed philosophical abstractions in the name of those who suffer under the lived abstractions of capital and its immanent philosophy (i.e., its norms, values, principles). "There is a perfect parallel," writes Kolozova, "between Marx's use of 'theory,' for which he also uses synonyms like 'philosophy,' 'abstraction,' and 'speculation,' and Laruelle's use of the term 'philosophy.' Marx argues for a materialism that will not be philosophical in the last instance, but rather one that will cause the meaning of the term to vanish."[64]

Kolozova invokes Marx's *1844 Manuscripts* to support her claim. Kolozova quotes the following lines: "we see how ... naturalism or humanism is distinct from both idealism and materialism, and constitutes at the same time the unifying truth of both."[65] Kolozova importantly returns to the *1844 Manuscripts*, precisely those writings deemed immature and non-scientific by Althusser, and there locates a non-philosophical ethos at the heart of Marx's concept of materialism. The "materialism" that *mattered* to the young Marx, Kolozova suggests, was not that of philosophy, but that naturalized by actually lived conditions given under the sign of "humanism" and "naturalism" but *not the philosophy of humanism and naturalism*. This real of lived conditions is not, however, an empirical core, or at least not one accessible by empirical methods, for empiricism is yet another philosophy. What then is this "real" of the human condition?

And what does it politically demand?

"The real in non-standard Marxism," writes Kolozova, "is analogous to what Marx calls the worker's 'interest.' The 'syntax of the real' that Laruelle argues for in *Introduction to Non-Marxism* is dictated by what one would call 'material reasons' or reasons originating from 'the real,' from the 'physical,' or from 'life,' according to Marx's *Capital*."[66] Kolozova suggests that it is precisely those moments in *Capital* where Marx is writing from and to the lived conditions of suffering that he actualizes what is most radical in his thought. It is there that he ceases speculation on capital and affirms its victims. Put shortly: the radicality of Marx, for Laruelle and Kolozova, lies not in what he says about capital, but what he says *against* it. It is when the analysis of capital turns to the physical conditions of the worker's interest, the section on the working day, for example, that Marx's non-philosophical radicality is most forcefully expressed. Contra Althusser, Marx is at his best when he is at his least "philosophical." Kolozova writes:

> The direct "interest" of the workers that Marx writes about is not an idea in the sense of a "causa finalis." It is not a purpose. It does not have a meaning per se. It does not require "wisdom," "superior knowledge," or education to know what one's interest is. Interest is experienced, it is lived. ... Philosophy, understood in Laruellian as well as in a Marxian sense, can drive us into violating our own interests by way of replacing the real (of life) with "truth." In Marxian terms, "fetishism" (and not only over commodities) can lead us to violate our immediate needs for a fulfilled life, which consists of a general state of physical and mental well-being.[67]

Capitalism is not simply a set of abstractions to be abstractly analyzed; rather capital should be critiqued from the standpoint of its physical effects on life. To feel exhausted at the end of

the work day, for example, is to spontaneously affirm the physicalism of capital. This exhaustion has no meaning per se although it certainly has a cause. No wisdom is required to understand it for it is immediately registered in the body. The body drained and bored by work is the immanent physical sign that such labor, though a requirement for life under capital, is not amenable to the goal of living a fulfilled life. It is the felt gap between the lived conditions of exhaustion and the visceral need for a more fulfilled life that capital, from the standpoint of the worker's interest, is immanently and physically understood.

Kolozova (via Laruelle) offers a powerful riposte to Althusserianism. To philosophically abstract or speculate on capital can lead us away from what our bodies know to what we think is the "truth" of the real under which we suffer. And this "truth" can end up being as much a fetish as any commodity. Althusserianism fetishizes "theory" in the name of producing real knowledge of capital, but where is the suffering and exhausted body in Althusser? What is politically emancipatory in further abstracting the abstractions of capital? In a sense, we find ourselves with Laruelle at the *end of philosophy* and *the beginning of Marx*. Laruelle writes:

> The drive to make Marx intelligible, of making him acceptable according to the philosophical norms of acceptability, has led to completing him instead of un-encumbering him, of taking away from him his postulates. ... If the "philosophical" problems of Marxism have a philosophical origin or cause, it will suffice to resolve them by determining the ensemble of its apparatus through the radical immanence of the Real, to substitute for its materialism-without-matter ... a real-without-philosophy.[68]

If what we still need is a "symptomatic reading" of Marx, then for Laruelle, this must be a reading that reads *philosophy*

as an ideological symptom that continually threatens to cut Marx off from what is real and radical – the worker's interest. Likewise, if there is an "epistemological break" in Marx, then for Laruelle, it is that between the *philosophical Marx* and the *non-philosophical Marx*; between the Marx fastened on the physicality of capital's real destructive power and the philosophical fetish of materialism. We might put the matter thus: non-Marxism defetishizes philosophical Marxism without abandoning what is emancipatory in Marxism. But the question then is: what operations of scission or *de-scission* are required to parse the philosophical Marx from what is most radical in his work? We find that here the specter of theory returns. Laruelle himself admits that there is no easy exit from theory.

Political Expression

Althusserian theoreticism may be accused of elitism and obscurantism. But it had the virtue of dealing with what has to be dealt with in any honest attempt to speak meaningfully of a Marxist political practice or the possibility for real existing socialism. It spoke to the need for a labor of theory – a necessary mediation – between idea and action.

I suggest that Althusser's insistence on the necessity of the autonomy of theory from practice was an important insight, for it saw the dangers of turning Marxism into a dogmatic ideology. But this insight generated its own oversight inasmuch as it reaffirmed the capitalist division of labor between mental and manual labor. Althusser had sketched a possible synthesis in the wager on the specificity of *theoretical practice*, but, as Badiou makes clear, this specificity was never specified in anything more than warmed-over Hegelian terms. The specificity of Althusserian theoretical practice would have to be (or become) a revolutionary practice of thought, meaning that it must follow through with the break with Hegel that began with the work of the mature Marx. It must then make a break with the

dialectic of theory and practice for a revolutionary *praxis* that would abolish the division between mental and manual labor by tearing down the walls between the group and the party, the factory and the office, the classroom and the street. And I would suggest, and this I can't imagine will come as a surprise, that the medium through which this radical integration can be sought is *aesthetics*. What Althusser never seemed to consider – despite his interest in art – is that theoretical writing is a *matter of writing* and as such involves the aesthetics of writing; from the force of polemics to the patient tone of the philosopher working through a problematic.

Where is the line to be drawn between the manifesto and the critical essay if not through the contested space of the aesthetic? Aesthetics is a tradition for dividing types of writing, types of speech, types of signs, types of images, types of performance. It is the intellectual practice of making distinctions between practices so as to identify and single out those practices which a culture is supposed to "appreciate." In its Kantian form, it seeks out that remainder of sensibility that seems to exist for itself independent of any "practical" use. It is this that, for example, allowed Duchamp's earliest champions to declare his readymade works – like his urinal-as-art, *Fountain* of 1917 – art for, robbed of its function, it appears to exist for the sake of its sheer presentation as such.

The most minimal operation of aesthetic judgment consists in the identification of forms of sensibility that appear to exist solely to be sensed. This liberal vision – art is that which is free (i.e., the liberal arts) from practical use – underwrites Althusser's blindness to the aesthetic force of his own theoretical practice – the force of his forceful writing. I am in a sense countersigning Derrida's important call to never forget the materiality of "writing" in the broadest sense as sign-making. But I am not countersigning a *Derridean* vision of pan-textualism. That vision lends itself to the forgetting of the actuality and embodied risks

of political practice. Rather, I am calling for a recognition of the labor of creativity in politics whether that be the creative labor of fitting words or bodies together. And this is not to superficially presume that this is the same kind of labor, but only to recognize the creative play and challenge that creative thinking poses in contexts of social and political control where the very room for such imaginative play is forcibly reduced to "free speech zones" or the norms of writing prescribed by the academy.

Slogans

To be yet more concrete, let me take up the concept of the slogan. "It is right to rebel."[69] "Demand the impossible." "We are the 99%." These are some of the memorable slogans of revolutionary practice. The slogan as a form strives to bridge theory and practice in the form of a kind of "thought-practice," for the slogan as a theoretical distillation is made for the practice of protest by chanting and yelling. It is a weapon. But it is also an aesthetic marker of solidarity articulated as an aesthetic praxis. One startlingly clear example of this is the case of *Quotations from Chairman Mao*, popularly known as the "Little Red Book."[70]

The book's canonical form – small, clad in red vinyl – came out in China in 1965. It is comprised of 427 quotations drawn from Mao's writings between 1929 and1964. The Little Red Book became synonymous with the Cultural Revolution by the images of Red Guards wielding the bright, pocket-sized book at mass rallies and demonstrations between 1966 and 1977. These images captivated Western radicals and led to the translation and mass production of the book in the U.S., East and West Germany, France, Italy and elsewhere.

Quinn Slobodian argues that in many contexts the Little Red Book operated alternately as a "badge book" and a "brand book." The former refers to those uses of the book as a badge of radical identity; the latter refers to those uses of the book as a fashionable accessory in the style of radical chic. The point is that the Little

Red Book could operate alternately (and simultaneously) as badge or brand due to its distinct aesthetic character. It was small, bright red, and clad in vinyl, like an army field manual. It immediately identified its carrier as someone with revolutionary interests beyond the theoretical.

The book of quotations functionally converted the quotes into slogans. Indeed, the very object of the book itself functioned as a slogan of revolutionary belonging or at least a desire to be seen as belonging. The book's very appearance signaled the potency of revolution articulated in the syntax of aesthetics, which is to say a revolution in and through cultural production. As the 1967 West German film, *The Words of the Chairman*, popular with radical students, put it: "we must cleverly transform" Mao's words. "In our hands they must become weapons."[71]

This weaponization took the form of radical cultural practices like film; the Little Red Book was transformed from an object of/for cultural revolution into a film, thereby circumventing the study of the actual book, and thereby further cementing the idea of the book as an aesthetico-political object of revolutionary cultural practice. Let me quote at length Slobodian's review of a set of aesthetico-political uses of the Little Red Book by West German activists of the 1960s, for it illuminates the concept of the slogan as aesthetic form:

> In activist provocations from 1967 to 1969, the Little Red Book acted as the textual equivalent of a tomato, a projectile favored by socialist students. When the police in Freiburg protested that students had no permit to sell books in 1968, they sold tomatoes "two deutsche marks each with a Mao as a bonus," likely implying that the tomatoes could be thrown rather than eaten. At times, the book itself was literally thrown. In May 1969, a student in Heidelberg hurled two Italian-language copies of the Little Red Book at a university instructor. ... At other times, the Little Red Book appeared amid an arsenal

of colorful provocations. A faculty member recalls finding a Bible spray-painted red after the evacuation of the occupied German Studies building at the Free University in May 1968, where a banner referencing Mao had hung reading "All Professors are Paper Tigers." The red Bible was likely a pun on the "Mao Bible," and an attempt to transubstantiate the *Urtext* of German letters – Martin Luther's Bible – into an accessory of revolt.[72]

These provocations, as unserious as they may appear, have theoretical content. Little Red Book as projectile, for example, performs, in the aesthetic register of humorous street theatre, the theoretical demand to cancel the theory-practice dialectic in the desire for words to wound. Likewise, the spray-painted Bible spontaneously demonstrates the felt need to translate the Cultural Revolution into the syntax of German print culture, in which the history of the Reformation could be seen as a prelude to a far more radical break with the moral economy of the "protestant work ethic," and with all species of "reformism" and conformism whether of actually existing socialism or liberal democracy. "All Professors are Paper Tigers" takes Mao's use of the slogan "paper tigers," which he used to delegitimize the legalism and proceduralism of Western politics, and transforms it into a weapon of denunciation of the social and cultural authority of the professoriate.

I do not mean to "elevate" these spontaneous actions as "theoretical labor." But I do mean to show that the difference between what is called "theory" and what is called "practice" or "action" may be understood aesthetically as *differences of form*. And that in instances like those iterated above, we are faced with a radically immanent casting of the distinction between theory and practice. In the very performance of sloganeering, the divisionary gesture of aesthetic distinction does not take place (whether it does later is another matter).

It is precisely in this immanent perspective, a kind of "vision-in-One" in Laruelle's terms, that we can reframe by analogy the specificity of Althusserian theoretical practice. We might state it as: theory is to theses as practice is to slogans. Althusser's decision, his splitting of these two forms of political speech, can only be stated axiomatically from a position of presumed authority – the authority of philosophy –vested and manifested in, again, what Laruelle would call "Philosophical Decision." In this formulation, Philosophical Decision in Althusserianism would consist of a decision for theses against slogans. But the *aesthetic similarity* between the slogan and the thesis is too great to ignore. Both are terse, cutting, breaking forms of statement-making, and each demands a *demonstration* by words or bodies whether in the classroom or the street.

Let me be clear: the aesthetic element of politics is by no means the exclusive possession of the Left. Indeed, Walter Benjamin thought that the aestheticization of politics was the essence of fascism. But his famed assessment is more punctual than universal. It sprang from Benjamin's admirable effort to diagnose the ways in which capitalo-fascist forces appropriated the means of Left aesthetic production, from the mass rally to the revolutionary aesthetic of montage (inaugurated by socialist cinema), and literally perverted them into the style and syntax of fascist politics. To aestheticize politics, for Benjamin, was to transform the content of politics into an image that, as an image, is severed from reason, whereas communist art is, theoretically, in service to the task of creating a more reasonable and humane society. This diagnosis was more utopian than historical as "socialist realism" transformed communist thought into vacuous images of heroic bodies engaged in obedient labor for the state and its protection. But what I want to challenge, however, is, following Laruelle, the dominant modes of discursive practice that regulate the aesthetics of theory. I want to conclude this chapter by placing Althusserianism within an invented

genealogy as the search for an aesthetic form of theorizing capable of surpassing the idealist construction of the theory-practice dialectic. I provisionally mark the start of this genealogy with the work of Karl Korsch.

The (Aesthetic) Ends of Philosophy: Korsch and Laruelle

In *Introduction to Non-Marxism*, Laruelle argues, in a somewhat stressed out fashion, that Marx's theoretical effort was an effort to *overcome philosophy*. Laruelle, in a sense, argues that Marx's famed eleventh thesis on Feuerbach – "philosophers have merely interpreted the world; the point, however, is to change it" – encapsulates the essentially radical relation of his thought to philosophy. Laruelle's strong reading of Marx's thought as a struggle against "merely" philosophizing or theorizing the world undoubtedly ventriloquizes his own thought; Marx as precursor to Laruelle's non-philosophy.

Laruelle holds that Marxism as a totality – as an idea – is entirely foreign to Marx's struggle against philosophy. The very idea of a "Marxist philosophy" reifies the practice of philosophically interpreting the world when the point of Marx's thought was to change it. For Laruelle, "Marxist philosophy" is the clearest and most tragic manifestation of the *ideology of philosophy* operating within Marx's syntax of emancipation.

Everything here hangs on how Laruelle interprets what Althusser called Marx's "immense theoretical revolution." Whereas Althusser argued that Marx's thought was divided by an epistemological break – the young Marx being bourgeois and humanist and the mature Marx being scientific and anti-humanist – Laruelle argues that the real break was that between philosophy and non-philosophy. This reading is not entirely without precedent. One important precedent is the thought of Karl Korsch.

Korsch takes the view that Marx's work, from his early

writings to his last ones, was committed to the overcoming of philosophy, but that he (and Engels) always understood this overcoming as requiring a *new form* of philosophical production. In *Marxism and Philosophy*, Korsch writes:

> In their early period Marx and Engels began their whole revolutionary activity by struggling against the reality of philosophy; and ... although later they did radically alter their view of how philosophical ideology was related to other forms within ideology, they always treated ideologies – including philosophy – as concrete realities and not as empty fantasies.[73]

Korsch's point, I take it, is that Marx and Engels took philosophy to be a material or concrete reality, which is to say, that they understood "ideologies, including philosophy," not as "empty fantasies" that could be easily waived away by prioritizing real material struggle. Marx and Engels's struggle against philosophy was a struggle against thinking that philosophy was "merely" a set of ideological fantasies. The eleventh thesis, for Korsch, was really a call for philosophy to be something *more* than the practice of interpreting the world; the classical form of hermeneutic philosophy had to be abolished. Korsch writes:

> There are three reasons why we can speak of a surpassal of the philosophical standpoint. First, Marx's theoretical standpoint here is not just partially opposed to the consequences of all existing German philosophy, but is in total opposition to its premises (for both Marx and Engels this philosophy was always more than represented by Hegel). Second, Marx is opposed not just to philosophy, which is only the head or ideal elaboration of the existing world, but to this world as a totality. Third, and most importantly, this opposition is not just theoretical but is also practical and active. ... Nevertheless,

this general surpassal of the purely philosophical standpoint still incorporates a philosophical character.[74]

The eleventh thesis on Feuerbach, according to Korsch, was a call for a *new form* of philosophy that would surpass the hermeneutic practice of theorizing the social and economic order. Korsch's *Marxism and Philosophy* singled out the theorists of the Second International (as did other early writers of the Western Marxist tradition) for their contradictory insistence that communist revolution was historically predestined by economic processes and their affirmation of Lenin's revolution. For if the revolution was predetermined by economic conditions, then the need to build and sustain a revolutionary party as Lenin did was unnecessary. But if such practical organizing was necessary then the "scientific" determinism of historical materialism had to be seriously called into question. The Second International, according to Korsch, failed not only to link theory and practice (or science and politics), but it had failed even to think the relation between the two. The opening lines of *Marxism and Philosophy* read: "Until very recently, neither bourgeois nor Marxist thinkers had much appreciation of the fact that the relation between Marxism and philosophy might pose a very important theoretical and practical problem."[75] *Marxism and Philosophy* tries then to demonstrate the urgency of this question and to trace Marx's effort to establish a mode of theorizing that could intervene upon the world and not merely interpret it.

Marxism and Philosophy suggests that while the relation between Marxism and philosophy was raised by Marx and Engels, the question was never settled by them. The eleventh thesis indicates, according to Korsch, that, with Marx and Engels, it became historically possible to think the "surpassal" of philosophy, but the form of this surpassal was never realized. This is why Korsch concludes his text somewhat enigmatically by quoting Lenin: "Philosophy cannot be abolished without

being realized."[76] The realization of "Marxist philosophy" would be the abolition of the quest to realize it and thus the abolition of the division between theory and practice *as conceptualized in classical idealist philosophies*. The end of philosophy via its realization is not the end of philosophy *per se*, but the end of what Korsch simply calls "bourgeois consciousness."[77] The end of idealist philosophy and the beginning of "the philosophy of the working class" would constitute a revolution in the form and content of philosophy and with it the destruction of the hierarchic division between manual and mental labor reified by capitalist relations.[78]

However, Korsch's text is itself constitutively unclear on what its relation to Marxist philosophy is. Is it to be read solely as a critique of the Second International's failure to think the question of the relation of Marxism and philosophy or is it a demonstration of how this thinking is to be done? If it is the latter, then the answer seems to be that the method that should be adopted is what Martin Jay identifies as Korsch's "radical historicism."[79] There is evidence for this reading in the very means by which Korsch historicizes Marx and Engels's drive to think (if not realize) the surpassal of classical idealist philosophy. Does Korsch suggest that the surpassal of philosophy begins with its historicization? Perhaps. Korsch writes:

> The correct materialist conception of history, understood theoretically in a dialectical way and practically in a revolutionary way, is incompatible with separate branches of knowledge that are isolated and autonomous, and with purely theoretical investigations that are scientifically objective in dissociation from revolutionary practice.[80]

However, historicism cannot possibly accomplish the surpassal of philosophy for the simple fact that historicism is not a new form, but is itself historically tied to the articulation of idealist

philosophies of history. And while historicism embraces all branches of knowledge production in its theoretical framework – anything can be historicized – historicism itself is a discrete intellectual practice – one branch only.

Part of what is interestingly problematic about *Marxism and Philosophy* is its own form; it is a searching text that wavers between historicism, philosophy, and polemical intervention as if it is itself, perhaps symptomatically, perhaps unconsciously, searching to accomplish by its aesthetic form the realization of philosophy's surpassal only indicated as a potentiality in the writing of Marx and Engels. As Patrick Goode, in his study of Karl Korsch, notes:

Why did Korsch think that the neglect of the problem of Marxism and philosophy was so significant? The answer to this question is not easily found in Korsch's book – indeed, one of the problems in understanding *Marxism and Philosophy* is to determine precisely what its problematic is, because it is not set out very clearly or systematically in the work itself. Korsch's major work on philosophy, although it only runs to seventy-odd pages, is always complex and often obscure. Perhaps over-reacting to the systematization involved in the normal presentation of academic philosophy, Korsch presents his ideas very fluidly.[81]

In 1930, Korsch published *The Problem of "Marxism and Philosophy"* in an effort to address certain lacunae in his 1923 text and to try to clarify his intent (perhaps to himself as much as his readers). Korsch writes: "*Marxism and Philosophy* advanced a conception of Marxism that was quite undogmatic and anti-dogmatic, historical and critical, and which was therefore materialist in the strictest sense."[82] What could this possibly mean? How is a text which is both "historical and critical" to be understood as "materialist in the strictest sense?" I want to suggest that what

is at issue here is Korsch's symptomatically stressed attempt to find a *form* of theorizing capable of thinking critical thought (theory) and history (practice) as immanently unified.

I am somewhat forcibly placing Korsch within a lineage of "non-Marxist" thought of which Laruelle is but the latest variant. That is to say, what Korsch seemed to be searching for was a form in which to state Marxism in anti-dogmatic fashion in fidelity to the desired surpassal of philosophy envisioned by Marx and Engels at their most radical. But what is key is that this desired surpassal is understood as a problem of form or a certain aesthetic of re-presentation. That form – part history, polemic, philosophy, pamphlet – required Korsch to defetishize orthodox Marxist philosophy. Whereas this defetishization in Laruelle's work takes the form of "philo-fiction," an operation by which the writings of Marx (and Marxists) are treated as raw material for a thinking otherwise than philosophically in the standard sense; in Korsch it takes the form of an historicist presentation of Marx and Engels's work, but a historicism that tries to void historicism of its idealist legacy. But these gestures at surpassal are incomplete. The form is never explicitly theorized by Korsch, and Laruelle's work remains, as its title declares, an "introduction" to non-Marxism more than its achievement.

An Invented Genealogy

We have covered quite a bit of ground, but along the way we have constructed something like an invented genealogy of Althusserianism whose basic theoretical features predate and postdate Althusser's writings. Althusserianism is fundamentally oriented by the problem of the theory of theory: what is theory and what is its role with respect to history and political struggle? This much is clear to scholars of the Althusserian legacy. But what I have also argued is that this legacy or invented genealogy, stretching at least through Korsch, Althusser, Rancière, Macherey, and Laruelle, has been concerned with the question:

what form must be invented to think the surpassal of the division of labor between practice and theory? We may schematize this genealogy thus:

Korsch: theory as historicism without historicism
Althusser: theory as theoretical practice
Rancière: theory as an aesthetic that ruptures the distribution of commonsense
Macherey: theory as the presentation of a presentation
Laruelle: theory as philo-fiction

If, as Jodi Dean argues, the "comrade" as concept must be theorized, then it is certainly just as necessary to theorize the theorist.[83] The question that Dean and other theorists have to face is: what is a theorist? It is all well and good to demand that we theorize comradeship and party formation, but unless we interrogate this authoritative *demand to think politics* in the first instance then we are doomed to reproduce the division between mental and manual labor that Rancière rightly warns us against. The heart of Althusserianism, in the extended and invented genealogy that I have presented, is trapped in the problem of theorizing theory and the theorist in a capitalist mode; *the point is to change it*. What is required is that theorists conceive of their task as a creative practice of staging and framing the thinking of Marxism in a mode that defetishizes Marx's corpus and, by this defetishization, strips the allure of expertise upon which the theoretical dictatorship over political practice operates.

What needs to be remembered is that Marx's work was not only "scientific," but creative. It is the way he imagined an alternative to the present order that continues to make Marx's work inspiring over successive generations far removed from the industrial age in which he theoretically labored.

Chapter 5

Conclusion

I have argued that Althusserianism was underwritten by a disavowed aesthetic problematic immanent to Althusser's attempt to craft a theory of theory. Reading from the outside into the center of Althusser's writings – from his remarks on the drama of Bertolazzi and the painting of Cremonini into his theory of theory in his theoreticist phase – reveals the ways in which a certain aesthetics of presentation structures his theory of theory. In the "Letter on Art," Althusser tries (but fails) to maintain a distinction between art as the power to show and theory as the power to know. But this operation of distinction, what Laruelle might call Philosophical Decision, fails when read from the standpoint of Althusser's own writings on the problem of theoretical vision that he stages in *Reading Capital*. We find that Althusser's theory of theory in *Reading Capital* amounts to presenting what is already presented to vision: a presentation of a presentation. The line between aesthetics and theory is effaced in the Althusserian articulation of the theoreticist theory of theory.

What Althusser forced us to ask is: what is theory and what is (or should be) its role with respect to the data of history and ongoing political struggles? It seems that we can no longer innocently countersign his concept of theory as Marxist "science" not only because it rests on a highly speculative concept of an "epistemological break," but because the very idea of an autonomous field of Marxist science can only be unconvincingly distinguished from other modes of production, including art, as we have seen. But the value of the Althusserian tradition is to have raised the specter of this very question – the question concerning the theory of theory.

In the Verso conference, "Communism: A New Beginning?" – aspects of which have been uploaded to YouTube – Jodi Dean, after reading her paper, was asked by Susan Buck Morss what theory can do. Dean responded that theory can "provide weapons."[84] A powerful response. But it is also quite an opaque one.

What does it mean for theory to be a weapon? The response is not entirely dissimilar to Althusser's second phase theory of theory: "philosophy is class struggle in theory." But what does it mean to struggle in (with) theory? What does weaponized theory look like? How would we recognize it? Dean's response to Buck Morss is a slogan. And a slogan, as I have argued, is an aesthetico-theoretical practice. From the Little Red Book as projectile in West German activism of the 1960s to today's reinvigoration of the idea of communism; what needs to be accounted for is the aesthetics of theory as "badge" or "brand" and the way that theory aesthetically organizes modes of intellectual solidarity and struggle.

It is not that I am advocating for "reducing" theory to a supra-theory of aesthetics, but rather I am advocating for the idea of opening the question of theory at a meta-critical level that will be attentive to its modes of enunciation. We need to reconsider the question posed by Homi Bhabha in his landmark essay, "The Commitment to Theory": "In what hybrid forms," writes Bhabha, "may a politics of the theoretical statement emerge?"[85] In that same essay, Bhabha makes clear that it is prudent to respect that theory and political polemics serve different purposes, but the forms that serve these diverse purposes share an ambivalent set of rhetorical resources that are not always easily distinguished. "It is a sign of political maturity," writes Bhabha, "to accept that there are many forms of political writing whose different effects are obscured when they are divided between the 'activist' and the 'theoretical.'"[86] That is to say, that while there are differences between activist speech and theoretical writing, these differences

are matters of form as much as content. And to the extent that the aesthetics of each are not properly accounted for, then the differences between these forms are obscured by the ideological and capitalist distinction between theory and practice.

My hope is that in this short text I have reframed the problem of the aesthetics of theory (not to be confused with a theory of aesthetics) via an invented genealogy, beginning with Korsch and passing through Althusser, Rancière, Macherey, and Laruelle. The governing problematic that binds this genealogy is the problem of theoretical form. The question, variously addressed and variously resolved by each of these thinkers, is: what form must theory be presented in, what aesthetic form must it take, if it is not to merely reproduce the division of labor immanent to capitalist relations? What I have called for is to reframe how we understand the practice of theory, namely, to reframe that practice as importantly an aesthetic practice. We need to "return to Althusser" as Althusser "returned to Marx," which is to say that we need to return to Althusser's work and to its legacy to listen to what it says in its silence and what it stages and frames as absence, namely, the symptomatic question: what form must theory take that will not meta-critically reproduce the ideological division of labor against which all thought worthy of the name "Marxist" must continue to struggle against.

References

1. Louis Althusser, *For Marx*, trans. Ben Brewster (New York: Vintage, 1970), 167.
2. Louis Althusser, "Philosophy as a Revolutionary Weapon," in *Lenin and Philosophy and Other Essays*, intro. Frederic Jameson, trans. Ben Brewster (New York: Monthly Review Press, 2001), 6
3. Louis Althusser, "The Underground Materialism of the Encounter," in *Philosophy of the Encounter: Later Writings, 1978-1987* eds. François Matheron and Oliver Corpet, trans. G.M. Goshgarian (London: Verso, 2006), 174.
4. Louis Althusser, *For Marx*, 223.
5. Althusser, *For Marx*, 223.
6. Althusser, *For Marx*, 227.
7. Louis Althusser, *et al.*, *Reading Capital: The Complete Edition*, trans. Ben Brewster and David Fernbach (London: Verso, 2016), 268.
8. Althusser, *Reading Capital*, 278.
9. E.P. Thompson, "The Poverty of Theory or an Orrery of Errors," in *The Poverty of Theory and Other Essays* (New York: Monthly Reviews Press, 1978), 10.
10. Thompson, "The Poverty of Theory," 7.
11. Thompson, "The Poverty of Theory," 8.
12. Althusser, *Reading Capital*, 40-41.
13. Quoted in Althusser, *Reading Capital*, 18.
14. Althusser, *Reading Capital*, 22.
15. Althusser, *Reading Capital*, 19.
16. Althusser, *Reading Capital*, 20.
17. Althusser, *Reading Capital*, 24.
18. I am indebted to the extraordinarily valuable work of Gregory Elliott for the presentation of this schema. See, Gregory Elliott, *Althusser: The Detour of Theory* (Chicago:

Haymarket Books, 2009), 80.

19. Elliott, *Althusser*, 72-73.

20. Elliott, *Althusser*, 74.

21. Elliott, *Althusser*, 76.

22. Althusser, *Reading Capital*, 60-61.

23. Elliott, *Althusser*, 79.

24. Alain Badiou, "The Althusserian Definition of 'Theory,'" in *The Concept in Crisis: Reading Capital Today*, ed. Nick Nesbitt (Durham: Duke University Press, 2017), 23.

25. Badiou, "The Althusserian Definition of 'Theory,'" 23.

26. Warren Montag, *Louis Althusser* (Houndsmill: Palgrave Macmillan, 2003), 23.

27. Althusser, "The Piccolo: Bertolazzi and Brecht (notes on a materialist theatre)," in *For Marx*, 131.

28. Althusser, "The Piccolo," 131-132.

29. Althusser, "The Piccolo," 132.

30. Althusser, "The Piccolo," 133.

31. Althusser, "The Piccolo," 134.

32. Althusser, "The Piccolo," 134.

33. Montag, *Louis Althusser*, 25-26

34. Louis Althusser, "Contradiction and Overdetermination," in *For Marx*, 113.

35. Quoted in Montag, *Louis Althusser*, 23.

36. Quoted in Montag, *Louis Althusser*, 37.

37. Quoted in Montag, *Louis Althusser*, 37.

38. Louis Althusser, "Cremonini, Painter of the Abstract," in *Lenin and Philosophy and Other Essays*, 157-158.

39. Althusser, "Cremonini, Painter of the Abstract," 162.

40. Montag, *Louis Althusser*, 19.

41. Althusser, "Cremonini, Painter of the Abstract," 162.

42. Althusser, "Cremonini, Painter of the Abstract," 162.

43. Althusser, *Reading Capital*, 20.

44. Althusser, *Reading Capital*, 20.

45. Althusser, *Reading Capital*, 24.

46. Althusser, *Reading Capital*, 24.
47. Althusser, *Reading Capital*, 24.
48. Althusser, *Reading Capital*, 24.
49. Louis Althusser, "A Letter on Art: A Reply to André Daspre," in *Lenin and Philosophy*, 152.
50. Althusser, "A Letter on Art," 152.
51. Althusser, "A Letter on Art," 153.
52. I written on the problem of the aesthetics of aesthetics at some length in my work on Laruelle. See Jonathan Fardy, *Laruelle and Art: The Aesthetics of Non-Philosophy* (London: Bloomsbury, 2019); and Fardy, *Laruelle and Non-Photography* (London: Palgrave Macmillan, 2018).
53. Jacques Rancière, *Althusser's Lesson*, trans. Emiliano Battista (London: Continuum, 2011), xvi.
54. Rancière, *Althusser's Lesson*, 10.
55. Rancière, *Althusser's Lesson*, 11.
56. Jacques Rancière, *The Politics of Aesthetics: The Distribution of the Sensible*, trans., intro. Gabriel Rockhill (London: Continuum, 2011), 13.
57. Jacques Rancière, *Dissensus: On Politics and Aesthetics*, trans., intro. Steven Corcoran (London: Bloomsbury, 2015), 38.
58. Pierre Macherey, *A Theory of Literary Production*, trans. Geoffrey Wall, intro. Terry Eagleton (London: Routledge, 2006), 3.
59. Macherey, *A Theory of Literary Production*, 6.
60. Macherey, *A Theory of Literary Production*, 6.
61. Macherey, *A Theory of Literary Production*, 7.
62. François Laruelle, *Introduction to Non-Marxism*, trans. Anthony Paul Smith (Minneapolis: Univocal, 2015), 1.
63. Katerina Kolozova, *Towards a Radical Metaphysics of Socialism: Marx and Laruelle* (Brooklyn: Punctum, 2015), 2.
64. Kolozova, *Towards a Radical Metaphysics of Socialism*, 14.
65. Quoted in Kolozova, *Towards a Radical Metaphysics of Socialism*, 14.

66. Kolozova, *Towards a Radical Metaphysics of Socialism*, 2-3.
67. Kolozova, *Towards a Radical Metaphysics of Socialism*, 3.
68. Laruelle, *Introduction to Non-Marxism*, 10.
69. It is worth pointing out that the slogan, "It is right to rebel," comes from the *Little Red Book*. I have not cited it in fidelity to the public nature of this sentiment as a slogan.
70. I am indebted to the essays on the *Little Red Book* collected in a recent anthology. See Alexander C. Cook, ed. *Mao's Little Red Book: A Global History* (Cambridge: Cambridge University Press, 2014).
71. Quoted in Quinn Slobodian, "Badge Books and Brand Books: The Mao Bible in East and West Germany," in *Mao's Little Red Book*.
72. Slobodian, "Badge Books and Brand Books," 215-216.
73. Karl Korsch, *Marxism and Philosophy*, trans., intro. Fred Halliday (London: Verso: 2012), 72-73.
74. Korsch, *Marxism and Philosophy*, 74-75.
75. Korsch, *Marxism and Philosophy*, 29.
76. Korsch, *Marxism and Philosophy*, 97.
77. Korsch, *Marxism and Philosophy*, 97.
78. Korsch, *Marxism and Philosophy*, 97.
79. See Martin Jay, *Marxism and Totality: The Adventures of a Concept from Lukács to Habermas* (Berkeley: University of California Press, 1984).
80. Korsch, *Marxism and Philosophy*, 60.
81. Patrick Goode, *Karl Korsch: A Study in Western Marxism* (London: The Macmillan Press, 1979), 68.
82. Karl Korsch, *The Problem of "Marxism and Philosophy,"* in *Marxism and Philosophy*, 102.
83. See Jodi Dean, *Crowds and Party* (London: Verso, 2018).
84. https://www.youtube.com/watch?v=g4xC9LEU4Fw
85. Homi K. Bhabha, "The Commitment to Theory," in *The Location of Culture* (London Routledge, 1994), 33.
86. Bhabha, "The Commitment to Theory," 32.

CULTURE, SOCIETY & POLITICS

Contemporary culture has eliminated the concept and public
figure of the intellectual. A cretinous anti-intellectualism
presides, cheer-led by hacks in the pay of multinational
corporations who reassure their bored readers that there is no
need to rouse themselves from their stupor. Zer0 Books knows
that another kind of discourse – intellectual without being
academic, popular without being populist – is not only possible:
it is already flourishing. Zer0 is convinced that in the unthinking,
blandly consensual culture in which we live, critical and engaged
theoretical reflection is more important than ever before.
If you have enjoyed this book, why not tell other readers by
posting a review on your preferred book site.

Sweetening the Pill
or How We Got Hooked on Hormonal Birth Control
Holly Grigg-Spall
Has contraception liberated or oppressed women? *Sweetening the Pill* breaks the silence on the dark side of hormonal contraception.
Paperback: 978-1-78099-607-3 ebook: 978-1-78099-608-0

Why Are We The Good Guys?
Reclaiming your Mind from the Delusions of Propaganda
David Cromwell
A provocative challenge to the standard ideology that Western power is a benevolent force in the world.
Paperback: 978-1-78099-365-2 ebook: 978-1-78099-366-9

Readers of ebooks can buy or view any of these bestsellers by clicking on the live link in the title. Most titles are published in paperback and as an ebook. Paperbacks are available in traditional bookshops. Both print and ebook formats are available online.
Find more titles and sign up to our readers' newsletter at http://www.johnhuntpublishing.com/culture-and-politics
Follow us on Facebook
at https://www.facebook.com/ZeroBooks
and Twitter at https://twitter.com/Zer0Books